PHOTOGRAPHY
BEYOND
AUTO

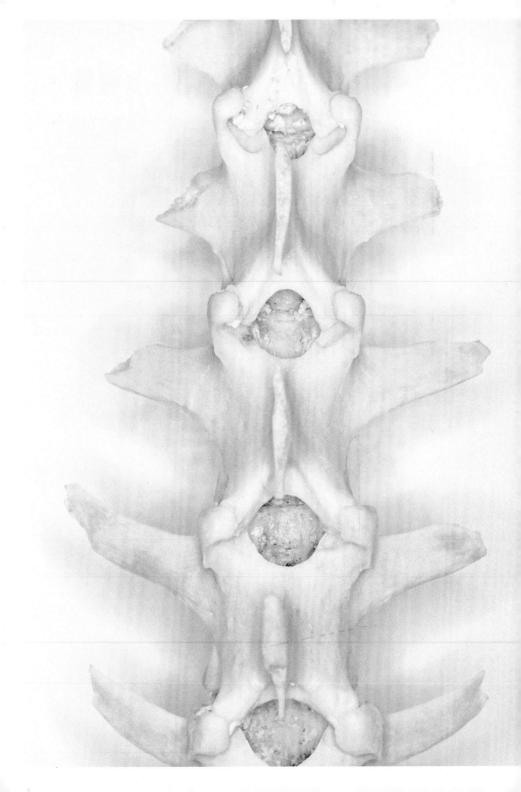

PHOTOGRAPHY
BEYOND
AUTO

Switch off Auto mode and take better, more original photos

CHRIS GATCUM

Photography Beyond Auto

An Hachette UK Company
www.hachette.co.uk

First published in Great Britain in 2015 by ILEX,
a division of Octopus Publishing Group Ltd
Octopus Publishing Group
Carmelite House
50 Victoria Embankment
London, EC4Y 0DZ
www.octopusbooks.co.uk

Distributed in the US by
Hachette Book Group
1290 Avenue of the Americas
4th and 5th Floors
New York, NY 10020

Distributed in Canada by
Canadian Manda Group
664 Annette St.
Toronto, Ontario
Canada M6S 2C8

Executive Publisher: Roly Allen
Associate Publisher: Adam Juniper
Senior Project Editor: Natalia Price-Cabrera
Senior Specialist Editor: Frank Gallaugher
Assistant Editor: Rachel Silverlight
Art Director: Julie Weir
Designers: Grade Design
Senior Production Manager: Peter Hunt

ISBN 978-1-78157-266-5

A CIP catalogue record for this book is available
from the British Library

Printed and bound in China 10 9 8 7 6 5 4 3 2 1

CONTENTS

INTRODUCTION

From the outside, what is thought of as proper photography with a DSLR or CSC (compact system camera) can appear to be something of a dark art—a mysterious amalgamation of science, technology, and art that requires years of experience to master and an encyclopedic knowledge if you want to "get it right." Today's cameras don't help either, with countless buttons, dials, menu options, and manuals that stretch to hundreds of (mind-numbing) pages. From the word "go" none of this is exactly intuitive, so it's unsurprising that a lot of people buying a DSLR or CSC for the first time will start out with the mode dial set firmly to Auto.

There's actually nothing wrong with this at all—whether you shoot using Auto or Manual, it's the pictures you make that really count, and Auto is capable of producing some stunning results. However, a little bit of knowledge can go a long way. It will help you when Auto gets things wrong (and it will), enabling you to set things straight rather than accept a disappointing result. More importantly, moving away from Auto means you can wrestle creative control away from your camera and actively set out to produce the results you want.

In this book, we're going to do precisely that. We're going to move beyond Auto without the jargon, unnecessary technicalities, or superfluous "fluff" that your camera offers, so we can concentrate solely on the essential skills you need to take better photographs. And, when you move beyond the security and safety of Auto, I guarantee that you and your camera can and will produce much more exciting photographs.

OPPOSITE: The only bull you'll find in this book (well, apart from the one on p52...).

01
AUTO

AUTO ROCKS!

There are people out there who would like to convince you that you couldn't possibly ever be a "proper" photographer if you shoot using Auto. They've got a point—Auto will limit you in a lot of ways. At the same time, it makes it a lot easier to get things right. I've seen (and taken!) some truly lousy shots using the "advanced" modes designed for "proper" photographers: bad exposure, bad focus, bad color, bad contrast, the list goes on... And in a lot of cases those "fails" simply wouldn't have happened if the mode dial had been set to Auto.

Of course, Auto's not infallible (then again, no camera feature is), but it is a lot more "serious" than it's given credit for. The thing to realize here is that "point-and-shoot" is not always a bad thing. With a single turn of the dial, Auto demystifies photography entirely, so you don't have to worry about which of the countless buttons, dials, and menu items on your camera need to be set, or how. That's a whole lot of technical know-how that you don't need to worry about, leaving you to concentrate fully on what it is you are photographing.

If you still need convincing, just look at some of the awesome shots on Instagram that have been taken using a smartphone—you can be pretty certain that most of them were taken with a fairly rudimentary camera rocking nothing more than an Auto mode.

ABOVE: The square format has been reinvented by
Instagram, which is host to hundreds of thousands
of Auto-originated moments in time.

WHY AUTO ROCKS

When you switch to Auto, your camera is going to take control of three key areas—exposure, focus, and color—so you don't have to worry about what's going on "under the hood." As a result, there's a very high probability that each and every shot you take will be well exposed, well focused, and color accurate. That's no small achievement.

Exposure: If you shoot in Auto you don't have to worry about balancing your aperture, shutter speed, and ISO to get an exposure that's "just right"—the camera will take care of that headache for you. It will also try to ensure that your shots aren't blurred through camera shake, and it may even add a burst of flash if it thinks it's going to help. All this, and you don't have to do a thing!

Focus: Your camera looks after all your focusing needs when the mode dial's set to Auto, locking on to your subject with minimum fuss and quite possibly tracking it across the frame if it moves. Using the full potential of the focusing system, Auto just wants to make sure your subject is tack sharp when you fire the shutter.

Color: When it comes to color accuracy, Auto mode's got your back. You don't need to concern yourself with color temperature or Kelvin, or even worry about what those things are to start with. In addition, your camera will tweak the level of contrast or sharpness, use highlight recovery when it's needed, apply noise reduction, and call on myriad in-camera controls that will help to optimize each and every shot you take.

OPPOSITE TOP: This heavily backlit portrait was taken using the camera built into an Android tablet. Auto has done a great job considering the challenging lighting conditions, with the extreme flare adding atmosphere to the image.

OPPOSITE BOTTOM: The best thing about Auto is simple: the camera will do everything in its power to optimize exposure, focus, and color. For this shot, nothing was needed beyond "point" and "shoot."

AUTO SUCKS!

From the previous pages you might wonder where we go from here—if Auto's so great at making our shots pixel perfect, why would we want or need any other modes on our cameras?

The simple answer is "control." Despite its technological prowess, your camera is ultimately a dumb picture-making box that doesn't know what you want to achieve when you press the shutter button, or how you want to do it. For example, your camera doesn't know whether that person closest to the camera is where you want to focus, or if they've just bombed the shot—all it can do is guess and hope it gets it right (a quick tip: most of the time Auto will pick the closest subject). It also doesn't know if you want the water flooding over that oh-so-gorgeous waterfall at sunset to be a silky smooth blur or if you want to see every single droplet. Again, all it can do is guess (and most times that means you'll get a result that's somewhere in the middle—not too blurred, not too sharp).

What's frustrating about this—and the main reason why Auto sucks—is that you're locked out of the process, so if the camera gets something wrong or guesses incorrectly, there's not much you can do about it short of telling people "the camera messed it up, not me." And there's a common saying about a poor workman blaming his tools…

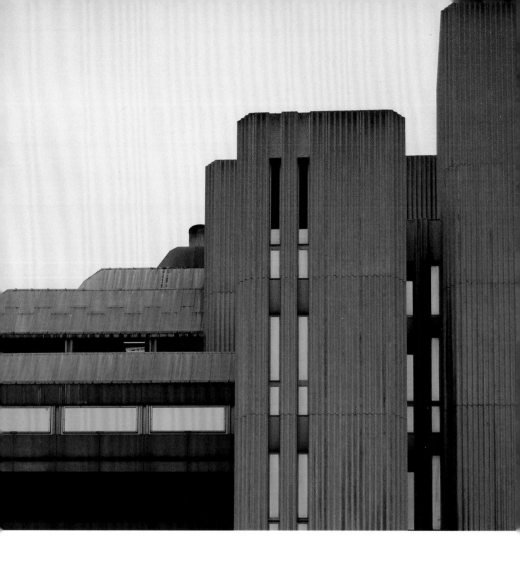

ABOVE: Today's cameras are so sophisticated that it's easy to forget that they don't know what you are photographing, or what you want to achieve when you press the shutter-release button. In this example, the large expanse of bright sky has "fooled" the camera into producing a slightly dark result—taking control of the exposure will quickly prevent this type of error from happening.

ABOVE: In addition to taking charge of the exposure, Auto will also decide how color should be dealt with. Here, the warmth and intensity of this sunset has been sucked from the image by over-zealous white-balance correction. This is not the camera's fault—Auto white balance is simply programmed to try and neutralize the colors in a shot.

WHY AUTO SUCKS

When you switch to Auto, your camera is going to take control of three key areas—exposure, focus, and color—so you don't have to worry about what's going on "under the hood."

I know, I know, I said the exact same thing a few pages back about why Auto rocks, but it works both ways. Why? Because when you switch to Auto your camera is going to take control, locking you out of most of the key photographic processes:

Exposure: When it comes to exposure, Auto tries to walk the "middle ground," avoiding the extremes of shutter speed and aperture, and restraining the ISO as much as possible. The results are unlikely to offend anyone, but they are equally unlikely to set pulses racing. In a word, it aims for "average" results that will suit most people, most of the time. But who aspires to "average?"

Focus: When you raise your camera to your eye (or hold it up to look at the rear screen), it's because you want to take a photograph of something. But your camera doesn't know what that "something" is, so it's simply going to guess where to focus. More often than not, that means it will look for a point toward the center of the frame, closest to the camera and with the highest contrast.

Color: The next time you witness a glorious sunset, set your camera to Auto, take a shot, and… prepare for disappointment. The problem is, Auto thinks you want your colors to be "neutral," so when there's too much of one color (the orange of a sunset, the blue of the sky at dusk, and so on) it compensates to control the bias. Consequently, that hot orange-red glow as the sun goes down is going to lose its vibrant intensity.

GOING BEYOND AUTO

As soon as you turn your mode dial away from Auto you make a huge photographic statement. With just one small click of the wheel you're saying "I know what I want to photograph." Even if you only switch as far as your camera's Portrait or Landscape setting you are starting to make choices and take control of your photography. And, once you know what you are photographing, then you can start to concentrate on how.

If you haven't guessed by now, there are three areas that you need to get to grips with when you move beyond Auto: exposure, focus, and color. We'll look at each of these in turn in the following chapters, but the most important thing is not to get overwhelmed by it all. It's easy to trip yourself up if you jump right in and start trying to work simultaneously on exposure and focus and color (and all they entail). This can often lead to disappointment and frustration, and—in the long term—less enthusiasm for picking up your camera to start with.

Instead, I'd suggest working through them one at a time. There's nothing wrong with setting your focus and white balance to Auto while you play around with exposure, for example, or switching to Program mode so your camera takes care of the exposure while you explore focusing or color. When you feel a little more comfortable, you can start to "mix and match" a little more—taking control of exposure and focus, but leaving the color decisions with the camera, for example. Before you know it, you'll be happily juggling all three.

ABOVE & RIGHT: Switching modes lets you take full control of your images, whether that means heightening color (top) or controlling depth of field (right).

BEFORE YOU BEGIN

Exposure, focus, and color will be the three main areas that we'll be exploring in this book, but before we get started you need to ask yourself a question: do you see yourself as a Raw shooter, or are JPEGs more your thing? These are the file formats offered by most DSLRs and CSCs when you move beyond Auto, and they basically relate to how your images are saved onto the memory card by the camera.

In general, there are three key differences between the two formats: bit depth, compression, and processing. The grid opposite will walk you through the subtleties, but remember that this isn't a question that you only ask once—you can chop and change from one to the other with every shot if you want to.

Personally, I shoot Raw and JPEG simultaneously for most shots, so I can decide which one to use when I've downloaded them to my computer. Most cameras offer a "Raw + JPEG" option. The downside is that every image is saved twice to the memory card (once in each format), so memory cards fill up quicker, and it also takes slightly longer to save them to the memory card (as you're effectively writing two lots of data to the card). As this can slow things up slightly, shooting JPEG only can be a better option for shooting burst of fast-moving subjects.

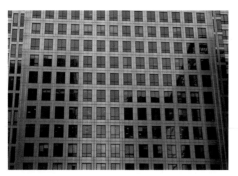 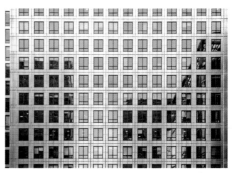

ABOVE LEFT & RIGHT: Shooting Raw lets you change your shots quite radically. This dull, gray office block was transformed into an enticing emerald tower with minimal effort.

	RAW	JPEG
Bit Depth	Raw files typically have a bit depth of 12- to 14-bits. In its simplest sense, the greater the bit depth, the more colors the camera can record, resulting in smoother tonal gradations and better color fidelity. The main benefit is that this extra color allows greater latitude when you process your images.	JPEGs are 8-bit files, but don't let the numbers fool you—an 8-bit image can reproduce 16.7 million colors, which is more than your eyes and brain can manage. However, if you start to process a JPEG too heavily on your computer the image will start to "degrade" more quickly than a Raw file, leading to a potential loss of quality.
Compression	Raw files are either saved to the camera's memory card in their entirety ("uncompressed") or the image data is compressed slightly (using "lossless" compression) so it takes up less space. Regardless of whether the image is compressed or not, a Raw file will take up more space on a memory card than a JPEG.	All JPEGs are compressed using a "lossy" process that discards data to make the file smaller. At the highest quality (lowest compression) setting this is unlikely to be noticed, but JPEG artifacts can appear when images are heavily compressed, or a JPEG is repeatedly opened and resaved (as a JPEG).
Processing	A Raw file is made up of the "raw" data from the sensor, without any in-camera processing (contrast, sharpness, noise reduction, and so on) applied. Instead, this processing happens on your computer, where you can use Raw-conversion software to make changes to almost every aspect of your photograph (even the exposure can be changed to a certain degree). The emphasis here is on extracting the best photograph from the "purest" image the camera can make.	When you shoot a JPEG, the camera processes the image for you, so the white balance, contrast, sharpness, and countless other settings are saved as part of the file. This makes it hard for radical adjustments to be made in your editing software without the image quality suffering, but then you shouldn't need to—the emphasis here is on getting the picture "right" in-camera so no additional tweaking is needed.
Best For	• Photographers who want the best image quality their camera's sensor can deliver, and aren't afraid to work for it. • Control freaks who need their white balance set to the nth degree, exposures within a fraction of a stop, and every other picture parameter set "just so."	• People who need their images NOW! A JPEG can be printed or uploaded the second it has been saved; a Raw file will need processing first. • Impatient snappers who would rather be shooting than sitting at their computer processing yesterday's photographs (or those from the previous week, month, or year…).

02
EXPOSURE

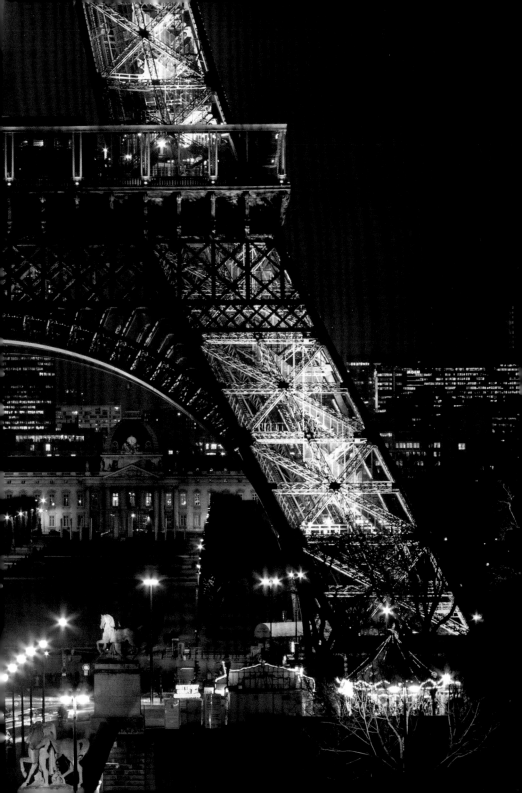

CRITICAL EXPOSURE

Exposure is at the heart of photography, playing a fundamental role in how your photographs appear. To a certain extent you could say that exposure is photography, because it not only influences the way in which movement is portrayed, and what is and is not sharp in an image, but it can also be the difference between "dark and brooding" and "light and airy," creating and enhancing the mood of a shot.

When your camera is set to Auto, you have absolutely no say in any of this, which is why a lot of shots taken using Auto look so… well… "average." But as soon as you go beyond Auto, you're free to decide how you want your images to look, and take your exposure settings to the extreme. This is when images get exciting. Taking control of the exposure is undoubtedly a big step up from the brainless button-pushing exercise that is your camera's Auto setting, but it really just comes down to one thing: getting the right amount of light to the sensor to produce the image you want.

BELOW: It doesn't matter what you're shooting, exposure comes down to one thing: getting the right amount of light onto the sensor for the right amount of time.

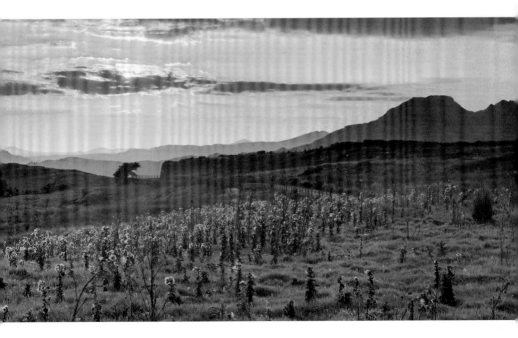

Exposure

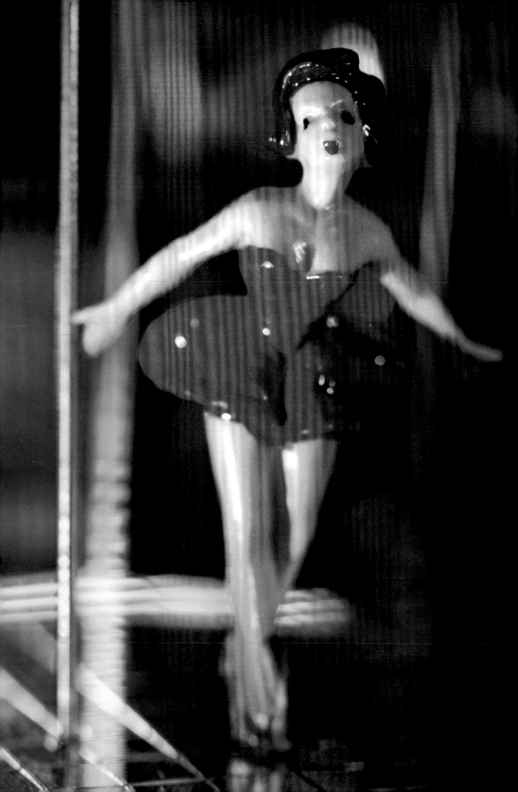

EXPOSURE'S HOLY TRINITY

Before we get down and dirty with exposure, there's one important thing to understand here: photography isn't like math. There's no right and wrong answer in the absolute sense, only what you think is right and what you think is not right—when I talk about the "right" or "correct" exposure, it simply means the one that gives you the result you are after.

Getting to the right exposure relies on three core camera controls, which have been in use since the very invention of photography. This "Holy Trinity" of exposure is the aperture, shutter speed, and sensitivity (or ISO).

Aperture: This is simply a hole in the lens that can be varied in size. A small hole (referred to as a small aperture) allows a small amount of light through the lens, while a large hole (also known as a large or wide aperture) allows more light to pass through the lens.

Shutter speed: Inside your camera is a shutter that opens to allow light to reach the sensor and then closes to prevent light from reaching it. The amount of time that the shutter is open for is the "shutter speed," which is typically measured in fractions of a second. The longer (or "slower") the shutter speed, the longer the sensor is exposed to the light passing through the lens. Shutter speed can also be called "exposure time."

ISO: Together, the aperture and shutter speed control how much light is allowed to reach your sensor and for how long, which is the basis of making an exposure. However, a third control is needed to determine how much light the sensor requires to start with. This control is the ISO, which determines how sensitive the sensor is to light.

OPPOSITE: Aperture, shutter speed, and ISO are at the heart of every exposure you make. With practice you'll soon be dancing with all three.

FILLING THE BUCKET

To make the right exposure, the aperture and shutter speed need to be balanced so that the sensor receives the correct amount of light for its sensitivity (ISO). This sounds pretty complex, so let's think of it like filling a bucket with water using a faucet. To put this analogy into photographic terms, the bucket is the sensor in your camera (the size of which is determined by the ISO); the size of the faucet is the aperture; and the time the faucet is running for is the shutter speed. The water equals light, and the aim is to fill the bucket, which will give us our exposure.

Now, a small bucket won't need much water to fill it, so we could use a small faucet and/or run the water for a short amount of time. On the other hand, a large bucket will need more water, so we would need to use a larger faucet to let more water through and/or run the water for longer.

To relate this more directly to exposure, setting a low ISO sensitivity setting is like having a large bucket, so you need more light ("water") to make the exposure ("fill the bucket"). This can be achieved by using a large aperture setting ("large faucet") and/or by letting the light reach the sensor for longer using a longer shutter speed ("a long flow time").

BELOW: Exposure is like filling a bucket with water: you need to balance the flow of water and its duration so the bucket is filled to the brim.

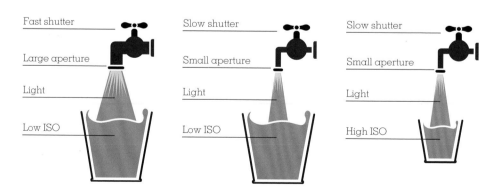

Fast shutter

Large aperture

Light

Low ISO

Slow shutter

Small aperture

Light

Low ISO

Slow shutter

Small aperture

Light

High ISO

On the other hand, set a high ISO and you've got a small "bucket," which means you need less light to make your exposure—the aperture can be smaller, or the shutter speed can be reduced. The bottom line is that you need to balance your aperture and shutter speed to the ISO: if you change the aperture, the shutter speed needs to be adjusted to compensate and maintain the same overall exposure, and vice versa.

This is fine so far, but between the largest and smallest buckets lie numerous other sizes, not to mention a range of faucet diameters and flow times that we can call on. On top of this, the water pressure (light) doesn't stay the same: sometimes there's plenty of it, other times a little. Add this all together and you can see how there are plenty of decisions to be made when it comes to producing the "perfect exposure"...

BELOW: Too much light hitting the sensor for too long will result in overexposure (left/bright); too little light for too short a time and you're looking at underexposure (center/dark). Get the balance right and that's your "perfect" exposure (right). In this case, I finished the image in DxO Optics Pro by reducing the vibrancy and adding a "glass" frame and faux light leak.

APERTURE & DEPTH OF FIELD

There's no escaping it, aperture is the least intuitive of all the exposure controls, and it's almost certainly going to require some "mental gymnastics" to tune your brain into how it works. Sorry, but here goes…

Aperture is expressed as an f-number or "f-stop," as illustrated opposite. As you can see, as the f-number increases, the aperture (which is the actual hole created in the lens) becomes smaller, allowing less light through the lens. This may seem counterintuitive (a bigger number should mean a bigger hole, right?), but it's because f-numbers are fractions. So, just as 1/4 is bigger than 1/16, f/4 is bigger than f/16.

Each aperture setting in the sequence opposite also represents a doubling or halving of the amount of light being let through the lens, so f/8 lets in half as much light as f/11, but twice as much as f/5.6, for example. This halving/doubling difference is known as "one stop" (so the difference between f/8 and f/11 is one stop, and the difference between f/8 and f/5.6 is also one stop).

Now, re-read this page until it sinks in: the "small number = big hole" equation is perhaps one of photography's least user-friendly rules, yet also one of its most important.

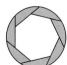

f/2.8

LEFT & ABOVE: Aperture controls two things: the amount of light passing through the lens and depth of field.

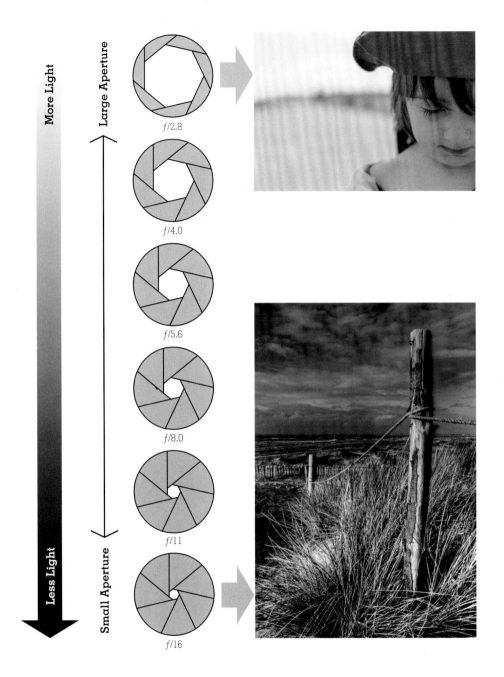

More Light

Less Light

Large Aperture

Small Aperture

f/2.8

f/4.0

f/5.6

f/8.0

f/11

f/16

ABOVE: All you need to remember about aperture is a bigger hole = a smaller f/number = a smaller depth of field. It's one of photography's harder lessons, but once you've got it in your head you're well on your way to mastering exposure.

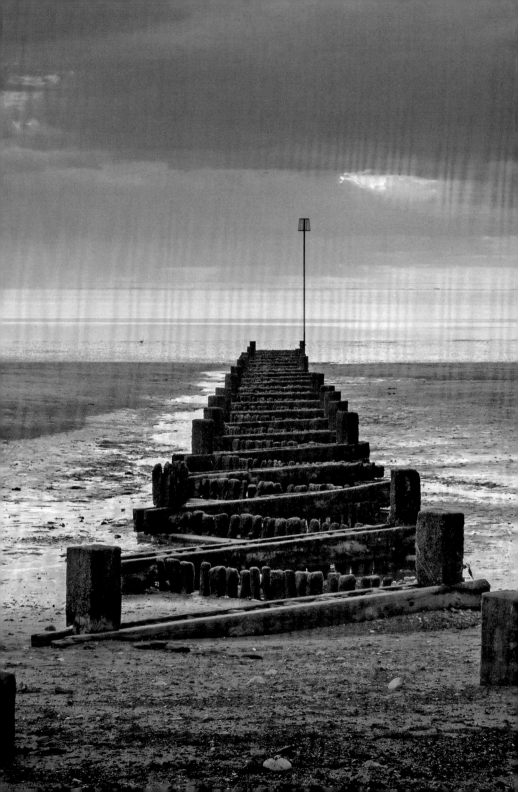

The aperture setting you use has a much more creative role to play than simply regulating how much light passes through the lens—it also determines how much of your photograph appears sharply focused. When you focus a lens, the distance that it's focused at will always appear sharp. However, you can use the aperture setting to create a "zone of focus" that extends in front of and behind your focus point, so that more of the scene appears sharp. This zone of focus is called "depth of field."

Controlling depth of field is an essential skill, as it's what allows everything in a sweeping landscape photograph from the closest detail to the farthest, to appear in focus or just the eyes to appear sharp in a portrait. The relationship between the aperture setting and depth of field is relatively straightforward: the smaller the f-number (f/2.8 or f/4, for example), the smaller the depth of field, and the less of the scene appears sharp; the bigger the f-number (f/16 or f/22, for example), the bigger the depth of field, and the more of a scene appears sharp.

At this point, a great exercise is to get someone to stand 10 feet (3m) from you and your camera, with a background maybe 20–30ft (6–9m) farther back (it doesn't matter if it's more distant, but don't have them stand right up against a wall). Switch the mode dial to A (or Av) to activate Aperture priority (we're already off Auto!) and set both the white balance and ISO to Auto (or ISO 200 if your camera doesn't have an Auto ISO option). Take several shots of your subject at a variety of aperture settings, from the largest to the smallest. Download your shots and take a look at how much of the image appears sharp at each aperture setting—that's depth of field in practice.

f/16

OPPOSITE & ABOVE: When you want to make sure that as much of your shot is in focus as possible, close down the aperture.

SHUTTER SPEED & MOVEMENT

The aperture setting may need a bit of time to get to grips with, but that's the hardest control dealt with—shutter speed is far more straightforward. This is because shutter speed uses something we're a lot more familiar with—time. The simple premise is that the shutter speed determines how long the sensor in your camera is exposed to the light coming through the aperture. On most cameras the shutter speed range runs from 30 seconds to 1/4000 second, which is enough to cover pretty much all eventualities. As with aperture, shutter speed is also referred to in "stops," with each stop equal to a doubling or halving of light (so 1/4000 second, 1/2000 second, and 1/1000 second are all one stop apart).

Just as the aperture has creative potential, so does the shutter speed, only this time it comes down to how movement in a scene is recorded. With a static subject, such as a building, it doesn't really matter what shutter speed you use: as the subject isn't moving, there won't be any change during the exposure whether you use a one-second shutter speed or a 1/1000 second shutter speed, so the end result would look pretty similar.

With moving subjects, the shutter speed you choose becomes more critical. If you use a slow shutter speed (say 1/2 second or one second), it's more than likely that your subject will move across the frame while the shutter is open. This movement will be recorded as blur in the final image.

RIGHT: When you shoot a static subject, the shutter speed is often irrelevant. It didn't matter if I shot this building at 1/250 second, 1/2 second, or 20 seconds—it wasn't going anywhere...

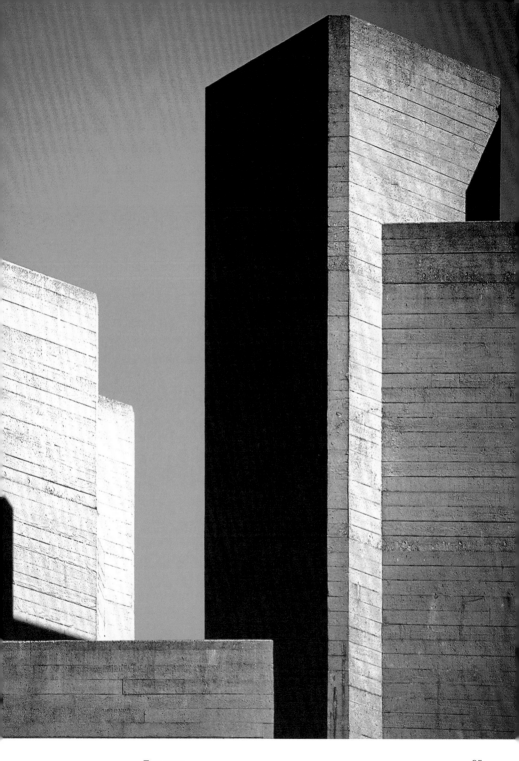

If you elect to use a faster shutter speed (1/60 second or 1/125 second, for example), your subject won't move as far while the shutter is open, so it will appear less blurred (or "sharper"). Use a faster shutter speed still and the distance your subject travels across the image will be even smaller (making them even sharper), right up until the point where the shutter speed is so fast that the movement isn't recorded at all and your subject is tack sharp.

Consequently, you can use shutter speed to control blur in an image, whether it's using a slow shutter speed to enhance blur and create a sense of action or motion, or a fast shutter speed to freeze even the fastest-moving subject.

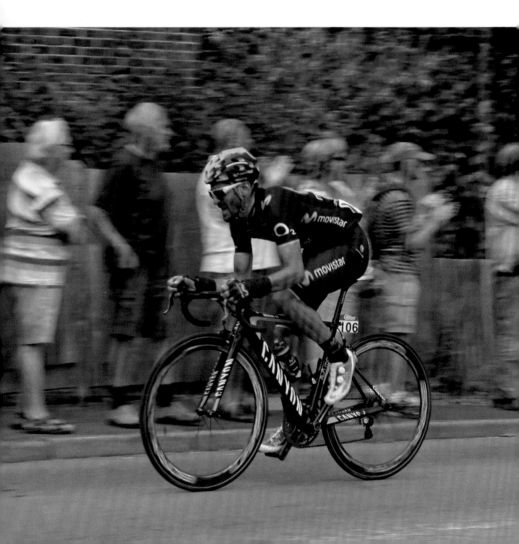

As a simple exercise in shutter speed, head to your local park. Switch your camera to Shutter priority mode (S or Tv) and—with the white balance and ISO set to Auto—photograph people walking, jogging, or cycling, using a range of shutter speeds from maybe 1/4 second through to 1/500 second to see how sharp (or otherwise) your shots are. You could also try "following" your subject with the camera while you use a slow shutter speed—this "panning" technique is a great way of implying movement without your subject blurring beyond recognition.

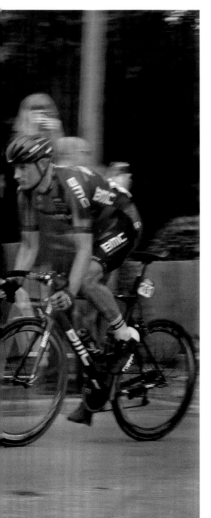

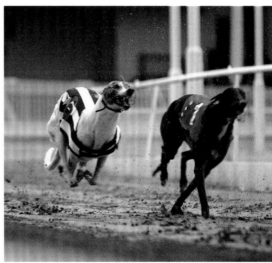

LEFT & ABOVE: Two different approaches to photographing a moving subject. In the first shot (above) I used a fast shutter speed of 1/1000 second to "freeze" the determined dog mid flight. For the second shot (left), I used a "medium" shutter speed of 1/200 second, and panned the camera to track the cyclists. As a result, they remain sharp, but the background is blurred.

ABOVE: As well as controlling movement, shutter speed can also be used to create movement. For this shot I set a deliberately slow shutter speed (1/2 second) and moved the camera during the exposure to create an atmospheric abstract.

Exposure

ISO & NOISE

The ISO film speed standard was introduced in 1974 as a measurement of a film's sensitivity to light, and it has since made the transition to digital photography. The ISO range seen in many of today's cameras has changed dramatically, though—whereas film speeds typically ran from ISO 25 (least sensitive to light) to ISO 3200 (most sensitive to light), modern digital cameras now go as far as ISO 409,600, indicating an exceptional sensitivity to light.

However, in digital photography, ISO no longer relates to a physical change in the sensor—instead, it refers to the "amplification" of the digital signal. The easiest way to think of this is that increasing the ISO is like turning the volume up on an analog radio to boost a faint transmission: the signal coming into the radio is amplified, and it comes out louder. On one level this is great, because it lets you pick up that weak broadcast that you really want to listen to, but at the same time, any crackles, hisses, and other unwanted background sounds will also be amplified.

The exact same thing happens with a digital camera when you crank up the ISO. As well as boosting the signal that's going to make your photograph, a high ISO setting will also amplify any non-image-forming elements that are introduced by heat on the sensor or even the circuits and components inside the camera. These non-image-forming elements are described—quite aptly—as "noise," which appears as a coarse texture or colored speckles in your photographs that will start to obscure fine detail and generally degrade the image.

ABOVE: Noise isn't always a bad thing, and a "grainy" texture can add atmosphere and give a shot a filmic quality. For this shot, I intentionally added noise during post-production to add some "grit" to the already-ominous sky.

MODUS OPERANDI

On the top of most DSLRs and CSCs (and a lot of other cameras as well) is a mode dial. This is your route to an Auto-less creative future and the place where you will likely find a selection of Scene mode icons and the mysterious "PASM" quartet (or P, Av, Tv, and M if you're a Canon or Pentax user). It's possible there may be additional options as well, such as Sv and TAv on the latest Pentax DSLRs.

The exposure mode (or "shooting mode," as it's also commonly called) tells the camera how much control you want over the aperture, shutter speed, and ISO. This can range from no control at all (as is the case with Auto and Scene modes) through to absolute power over the "Holy Trinity" (Manual mode). In between these extremes lie semi-automated modes (Program, Aperture priority, and Shutter priority) that offer control over one or two options, but not all three. We'll explore all of these options in more detail on the following pages, but for now take a minute or two to compare your camera's mode dial with the illustration opposite to see how it shapes up—you may not have as many modes on your dial (don't worry, you probably aren't missing anything essential!), or you might have more options to choose from.

Auto needs no explanation—set your camera to Auto (also symbolized by a green box on some cameras) and it will take care of everything for you, short of aiming the camera.

Flash off is "Auto sans flash." The camera will take care of the technicalities, but the flash will not fire no matter how necessary it is (or how politely you ask).

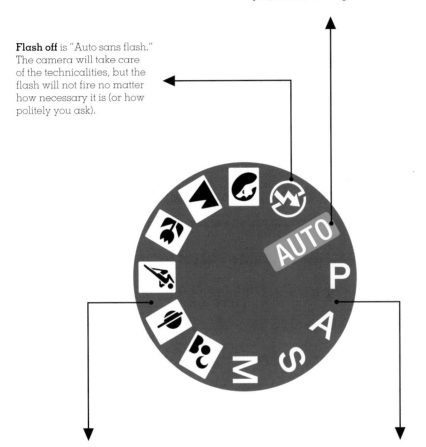

Scene modes typically cover everything from Landscape, Portrait, and Sports to slightly more esoteric options such as Pet, Food, and Underwater. Some of these might need to be accessed via the camera menus, rather than the mode dial, but if you have to go hunting for them it's a surefire sign that you don't really need them.

PASM are the classic abbreviations used for Program, Aperture priority, Shutter priority, and Manual mode: these are the modes to familiarize yourself with. Canon and Pentax cameras use Av (Aperture value) and Tv (Time value) instead of A and S, but only the name is different—in use they're the same as Aperture priority and Shutter priority.

LEAVE THE SCENE

If shooting with Auto is like going into the restaurant and asking for "some food," then using a Scene mode is like walking in and asking for "meat"—it will narrow the menu down a little, but it still doesn't guarantee that you'll get exactly what you're after.

As the catchall name suggests, these modes are designed for photographing specific scenes: Landscape mode for landscapes, Portrait mode for portraits, Sports mode for... well, you get the idea. This sounds great in theory, but Scene modes are only a small step up from Auto—the camera still sets exposure, focus, and everything else for you, locking you out of the process. The main difference is that while Auto approaches every subject in the same way, Scene modes shift the shooting parameters slightly, as detailed in the grid opposite.

However, despite the differences between the modes, each of them is still fully automated, which can lead to disappointing results if your subject doesn't fit neatly into the Scene mode's preprogrammed parameters—not all portraits are the same, for example, but Portrait mode will use a "one size fits all" approach. As you're locked out of the process, there's nothing you can do to remedy things when they go awry, so while setting a Scene mode at least tells the camera that you know what you're photographing, your creativity definitely deserves better.

OPPOSITE: Sports mode is a good option when you want to freeze fast-moving subjects, but a bit of atmospheric blur can create an even greater sense of "action." In this instance, Sports mode just wouldn't have been the right tool for the job.

MODE	TYPICAL SETTINGS
LANDSCAPE	• Small aperture for large depth of field (front-to-back focus) • Saturation and sharpness boosted
PORTRAIT	• Wide aperture for shallow depth of field (blurred background) • Neutral color and contrast to preserve skin tones
CLOSE-UP	• Small aperture for increased depth of field • Shutter speed set fast enough to minimize risk of camera shake
SPORTS	• ISO increased to allow fast, motion-freezing shutter speed
SUNSET	• White balance doesn't overcompensate for warm color of sky • Saturation increased for intense colors
NIGHT PORTRAIT	• Flash fired to illuminate subject • Long shutter speed to record (dark) background that isn't lit by flash

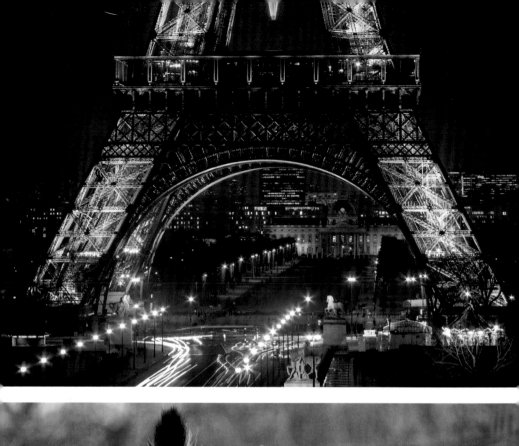

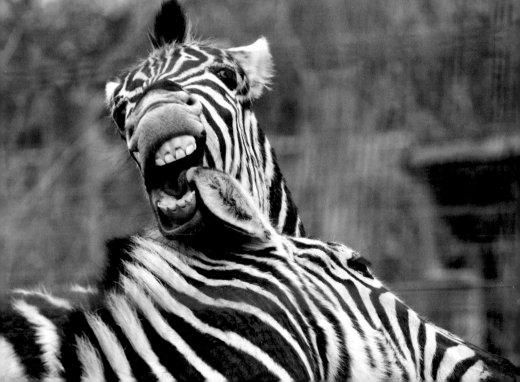

SWITCH THE PROGRAM

In some regards, Program is very similar to Auto, which is why some cameras refer to it as "Programmed Auto." As with Auto mode, Program asks the camera to set the aperture and shutter speed automatically, but it doesn't lock you out entirely: you get to choose the ISO setting, the white balance, and tweak all the other picture parameters your camera has to offer.

More importantly, you can shift the exposure that the camera suggests by using something called "Program shift" (or "Flexible shift" or similar, depending on the make of your camera). What this neat trick does is let you adjust the aperture and shutter speed combination set by the camera, without affecting the overall exposure.

So, if the camera says $f/8$ at 1/125 second, but you want more depth of field, you could shift the aperture setting to $f/16$ and the shutter speed would automatically change to 1/30 secondto maintain the same overall exposure. Similarly, if you want a faster shutter speed, you could shift it to 1/500 second and the aperture would change to $f/4$—again, the same overall exposure. However, you won't have access to the full range of your exposure controls—if the scene requires, say, 1/250 second at $f/2.8$ (and say that's the maximum aperture of your lens), Program shift will prevent you from setting shutter speeds higher than 1/250 second.

This makes Program a great "go to" mode when you decide you want to get more from your camera, because you can use it in multiple ways, depending on how much (or how little) control you want. You can set the ISO and white balance to Auto so you can concentrate fully on your exposure settings, for example, or you can tweak your exposures, ISO, white balance, and any other picture control you might happen across.

OPPOSITE TOP & BOTTOM: The advantage of using Program is that you can override the exposure settings suggested by the camera. Want to freeze some action? No problem—just set a faster shutter speed (left/zebra). Want to introduce some motion blur? Sure thing—just extend the shutter speed (top/Eiffel tower). In each instance, the camera will do its very best to maintain the same overall exposure.

GIVE ME PRIORITY

Your camera's priority modes (Aperture priority and Shutter priority) are referred to as "semi-automated" exposure modes because control over the exposure is split between you and the camera. In both modes you have absolute control over ISO, white balance, and other picture parameters, as well as either the aperture or shutter speed (but not both).

In Aperture priority mode, you set the aperture you want to use and the camera sets the shutter speed that it reckons will give the correct exposure. In this way, you can decide whether you want to use a wide aperture for a really

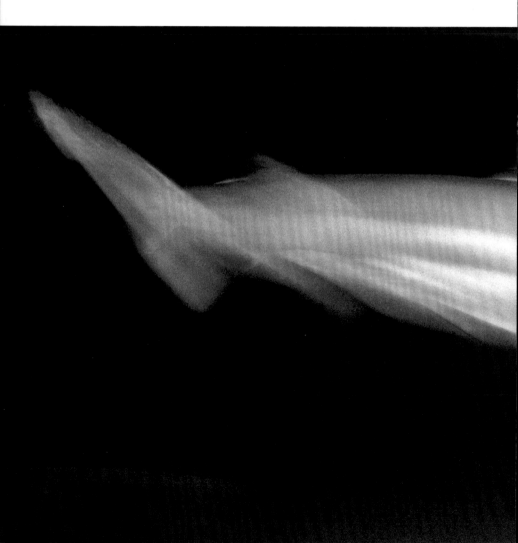

shallow depth of field, a small aperture to keep everything sharp, or something in between. Switch to Shutter priority and the roles are reversed—you set the shutter speed (to control movement) and the camera chooses the aperture that's needed to expose your shot.

BELOW: Should you want to use an extended, blur-inducing exposure time (below), Shutter priority is your go-to mode when shutter speed is most important.

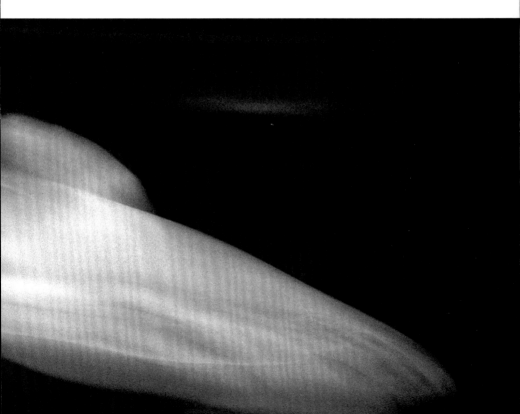

"But wait!" I hear you cry "Doesn't Program mode also allow me to adjust the aperture and shutter speed via Program shift?" Well, yes it does, but the camera remembers the aperture or shutter speed on a shot-to-shot basis when you're in a priority mode, whereas Program will usually forget any exposure shifts as soon as a photograph is taken (or, equally annoyingly, apply them to each and every shot). So while you can use Program to achieve pretty much the same thing as the priority modes, you'll likely have to tune each and every exposure.

Care has to be taken with the priority modes, though. Unlike Program, the camera will allow you to set any aperture or shutter speed, even if it can't match it to make a good exposure. This means you can set an ultra-wide aperture that would require a faster shutter speed than the camera has, or you can set a shutter speed that would require a smaller aperture setting than the lens provides. The camera will warn you when this happens, but it won't stop you from taking a shot, even though it knows the exposure is going to be way too light (or dark).

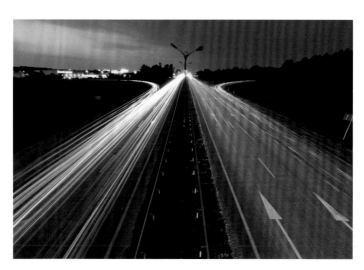

ABOVE: When you use a priority mode, you can step outside the camera's capabilities. For example, most cameras allow you to set a maximum shutter speed of 30 seconds. This might be enough for some subjects (such as these vehicle light trails), but it would be far too short for shooting star-trail images.

OPPOSITE: Getting front-to-back sharpness was the name of the game for this "classic" landscape, which meant maximizing the depth of field. Aperture priority allowed me to do just that.

MANUAL

Manual mode gives you full control over your camera, and certain "hardcore" types will tell you it's the only mode you should be using if you want to be a proper photographer. Don't listen to them. In the real world, a priority mode and exposure compensation (discussed on page 62) can do most things that Manual can, with less chance of tripping yourself up on the way. There are exceptions, though. The first is ultra-long exposures, such as star trails or painting with light, which exceed your camera's maximum shutter speed (usually 30 seconds). In this case, you'll need to switch to Bulb mode, which will let you manually hold the shutter open for as long as you want (or until the camera's battery runs out).

Manual mode also allows a neat trick that could be called "Manual priority." If your camera lets you set the ISO to Auto, you can dial in the aperture and shutter speed you want (to get both the depth of field and movement control you desire) and the camera will adjust the ISO to give the correct exposure. This was simply impossible when shooting on film and still cannot be achieved on some cameras (unless you're using a Pentax camera, in which case TAv mode does the exact same thing).

Finally, you might hear people talking about using old lenses from film cameras on their DSLR; or using lenses that were designed for a different system (Nikon lenses on Canon cameras, for example); or trying a host of other lens-based coolness, from Lensbabies to pinhole and "freelensing." In each case, a lot of cameras will only let you do this if you switch to Manual.

OPPOSITE: This shot was taken using a technique known as "freelensing," (not attaching a lens at all). On most cameras, such lens-based shenanigans are only possible when you switch to Manual.

SEEING THE LIGHT

So you've seen which camera controls you need to use to make an exposure, and the various modes you can call on to exploit them, but how exactly do you know what the "right" amount of light is to start with? This is where exposure metering comes in.

Every digital camera has a built-in "exposure meter" (or "light meter"), which uses one of several metering "modes" to measure the light falling onto the scene or subject you want to photograph so it can determine how much light it thinks you're going to need to make that perfect exposure.

However, before we look at metering modes, there's an important thing you need to appreciate: an in-camera exposure meter assumes that every single scene you photograph has "average" reflectivity. This means that if you took all of the tones in an image—from the brightest highlight to the deepest shadow—and averaged them out, you would end up with mid-gray. Think of it like painting in black and white: if your potential photo was painted in black and white, and you smeared all the paint together before it had dried, the camera would expect the result to be mid-gray.

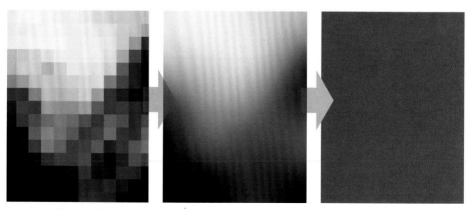

ABOVE & OPPOSITE: The simplistic simulation above shows how the image opposite would "average out" to mid-gray, as the light and dark areas balance each other out.

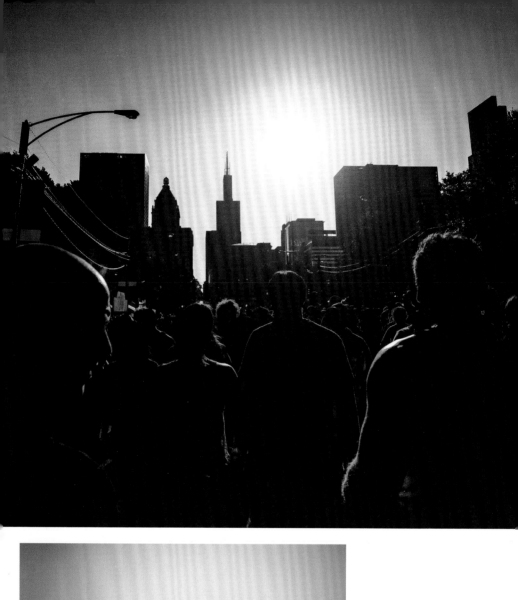

BEYOND AVERAGE

So what's the problem with this mid-gray world your camera thinks it lives in? Well, your camera not only expects a scene to average out as mid-gray, but it's also programmed to set the exposure so that it delivers this mid-gray average (so what comes out of the camera matches what it assumes is coming in).

Of course, this isn't always the case—sometimes a scene might be brighter than average (think snowy landscapes, beaches on a sunny day, or when you're shooting into the sun) or darker overall (night shots, for example). When this happens, the camera's exposure meter will quite possibly be "fooled" into producing a shot that is darker or lighter than expected. Consequently, the camera will darken down a particularly bright scene to meet its preprogrammed mid-gray ideal, while that mean-and-moody urban night scene that you want to shoot will be brightened up so those inky black shadows become mid-grays and the atmosphere is lost.

This isn't a fail on the part of the camera, it is simply that your camera doesn't know what it's looking at—modern camera's are sophisticated, sure, but at the end of the day they are still just lumps of metal, plastic, and glass.

The good thing here is that your camera will be consistent in getting it wrong. Because it's not trying to second-guess the situation, your camera will repeatedly fall short in similar situations, so you can learn to predict when it might struggle and when to then set a different metering mode to help it out, or tweak the exposure to compensate.

OPPOSITE TOP: Shooting into the sun guarantees underexposure, but it is also a great way of producing striking silhouettes.

OPPOSITE BOTTOM: Point your camera at an overly bright scene and the result is inevitable: your shot will be underexposed unless you tell your camera to compensate. However, for this minimal snowscape (which was taken in Manual mode using a plastic "Holga" lens on a DSLR), the soft gray tones were preferable to a stark white image.

MULTI-AREA METERING

Every camera has a multi-area metering mode, although it goes by many different names—Evaluative (Canon), Matrix (Nikon), Segmented (Pentax), or Multi (Sony). Despite the varying titles (and subtle differences in the programming behind them), the essence of multi-area metering is the same: the camera takes exposure readings from multiple areas covering the entire frame. These individual light readings are then assessed and averaged out to deliver a single overall exposure.

Multi-area is the default exposure mode for most cameras, and for good reason—because the camera is metering for the scene as a whole, no part of your picture is omitted. This means the full tonal range is considered, from the tiniest highlight to the deepest shadow, and the exposure is set based on which tones occupy the largest part of the image area.

However, this is also multi-area metering's shortfall: large areas of light or dark at the edges of the frame (which are usually not a key part of a shot) can influence the overall exposure more than they should.

OPPOSITE & ABOVE: Multi-area metering takes independent light readings from different zones or areas of the frame. The simulation opposite, shows (roughly) how the camera "read" the color shot above.

CENTER-WEIGHTED METERING

While your camera's multi-area metering mode assesses the scene as a whole, center-weighted metering gives greater priority to the center of the frame, based on the simple notion that this is where the important part of a picture is often found. This can be especially useful for portraits, as the exposure will be set for that big round face at the center of the frame. It doesn't really matter too much if the background is light, dark, or anywhere in between—the metering mode simply biases the reading in favor of the central portion of the frame.

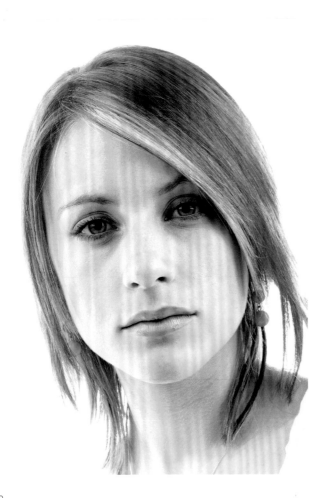

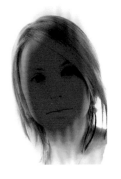

LEFT & ABOVE: Center-weighted metering was ideal for this studio portrait, as it meant the bright white background didn't overly influence the camera's exposure meter (if it had, it would have led to an underexposed image).

SPOT METERING

Spot metering is a super-precise metering mode that measures the light from a very small and specific part of the frame (usually the center, although some cameras allow you to link the spot meter area to the focus point). The advantage here is that you can decide precisely which part of an image to set as your mid-tone (tip: the sidewalk, sunlit grass, or a gray rock will all make good reference points). However, you need to be careful: choosing the wrong target area is going to take you straight to exposure disappointment.

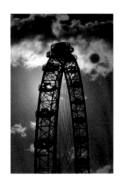

RIGHT & ABOVE: Spot metering lets you select a very precise "target" for your exposure reading. Here, I metered from the bright, backlit clouds to throw this iconic London landmark into silhouette. Using Manual mode let me take the reading from the sky, set my aperture and shutter speed, and then reframe the shot.

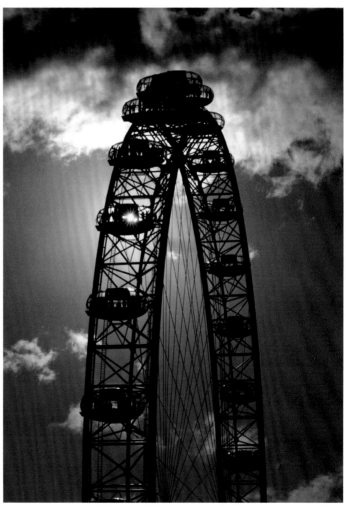

COMPENSATION & BRACKETING

Whether the camera's been fooled into giving you the "wrong" result or you simply want to change the mood of a shot, there will be times when you'll want an exposure to be a little brighter or a little darker. If you can't shoot the image again, you'll just have to wait until you're back at your computer and use your software to make your images lighter or darker, but if you have the luxury of time and your subject isn't going anywhere, there's no excuse not to shoot again. ("I'll fix it in Photoshop" is pretty lame when reshooting will only take seconds of your life.)

The tool you need to fix your exposure woes is exposure compensation, which usually has its own dedicated button within easy reach of the camera's shutter release. By pressing and/or holding the button and turning a control wheel, you can brighten the exposure (using positive/+ compensation) or darken the exposure (negative/- compensation) for the next shot you take.

Alternatively, you can increase your chances of success by using automatic exposure bracketing (your camera may have a button for this as well, marked AEB). When you activate exposure bracketing, your camera will adjust the exposure across a number of images, so you can shoot the same subject with a range of exposures—some brighter, some darker, and one in the middle. Usually this is done across three or five shots, with a view to choosing the "best" exposure later on.

━━ Compensation ◀━━━━━ Recommended exposure ━━━━━▶ Compensation ✚

ABOVE & OPPOSITE: Exposure compensation in action. The shot in the center is the exposure recommended by the camera for this idyllic sailing scene; the shots to the left have had negative exposure compensation applied; those to the right have had a positive exposure compensation applied. In this instance, I was happy with the recommended exposure, but you can see that a brighter version would have worked as well.

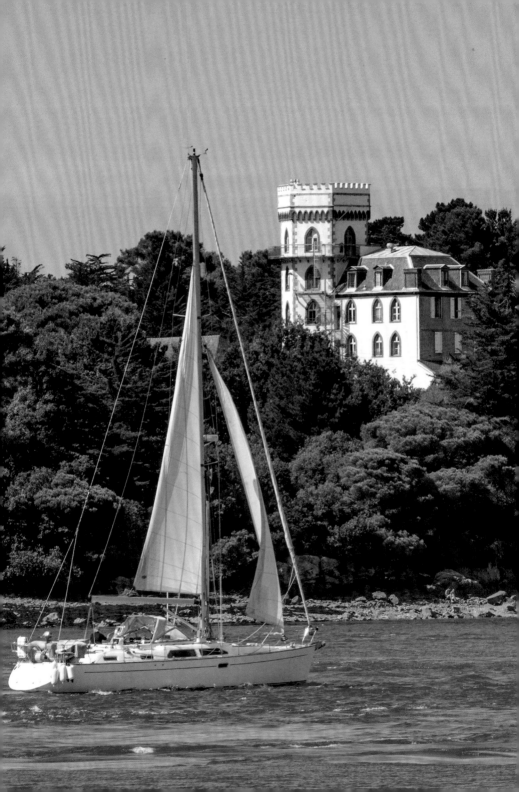

HISTOGRAMS

Histograms are your path to exposure success, no matter what shooting mode you use or which metering pattern you call upon. They may just appear to be tedious little graphs, but what those graphs are showing you is exposure gold— once you understand how to read them.

You can call up a histogram after you've taken a shot, although some cameras will also let you see a very useful "live" histogram when you use the rear screen to frame your shots. Either way, when you look at a histogram you are looking at the distribution of tones in an image: the left end of the graph is black; the right end is white; and the mid-tone areas are (unsurprisingly) in the middle.

If the histogram is shifted to the left, it means the tones in the image are shifted toward the "dark side." This could simply mean you're photographing a dark subject or—and this is where the histogram helps your exposure efforts—it could be indicative of underexposure. Conversely, if the histogram is shifted to the right, it tells you that your image is primarily

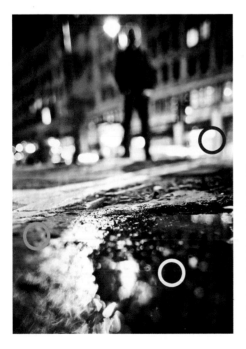

LEFT & ABOVE: The histogram for this image shows a full range of tones from shadows (left edge) to highlights (right edge), although the fact that the graph is "stacked up" at the right indicates that some of the highlight areas are burnt out, or pure white. The colors have been added to the histogram to show how the graph relates to the tones in the image.

made up of bright tones—if you aren't photographing an especially bright subject, then the image is probably slightly overexposed and a small amount of negative (-) exposure compensation is needed.

A histogram will also warn you when the extremes of the tonal range have been "cut off." If the histogram piles into the left edge then certain areas are pure black (with no detail), while if the graph crashes into the right edge your brightest highlights have become pure white. In both instances, this "clipping" might need looking at—detail that isn't recorded when you shoot cannot be recovered later, no matter how hard you try.

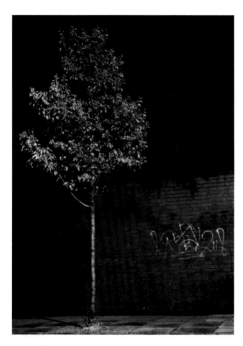

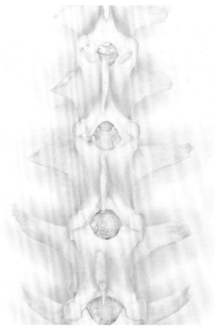

ABOVE: This histogram is shifted to the left, which means one of two things: a predominantly dark subject or underexposure. In this instance, it's a dark, moonlit scene—the exposure is fine.

ABOVE: A histogram that's shifted over to the right means either an overexposed shot or a mainly light subject. As I wanted a light and airy ("high-key") feel to this spinal study, I have no problem with the exposure as it is.

GETTING FLASH

Almost all cameras have a built-in flash of some description, whether it pops out of the top or is fixed in place like the flash in most compact cameras. Even a lot of cellphones have a built-in flash.

The main reason why flash is so ubiquitous is because you cannot make an exposure without light. Although ISO settings have soared to near-incomprehensible (and almost certainly unnecessary) levels, you still need some light to be able to use them, and the established method for throwing light onto a photographic subject is electronic flash. However, just because it's there doesn't mean it has to be used. It certainly shouldn't be seen as a low-light solution that needs to be activated every time you're shooting indoors or after the sun has set (more on that later).

At the same time, though, flash shouldn't be seen as some sort of atmosphere-sapping light-demon that needs to be avoided at all costs. Yet that is precisely how some people treat it, refusing vehemently to activate it, regardless of what it is they are shooting.

Instead, think of flash as an option for each and every shot you take, regardless of the light level: something that you might use, but equally, might not. The fact is, flash can make a great shot even better, but it can also ruin your photographic endeavors pretty quickly. It all depends on what it is you're shooting and what it is you are hoping to achieve. With that in mind, let's run through the essential flash skills that will help you get the best from your in-camera flash, and what to look for if a "strobist" future is on the cards.

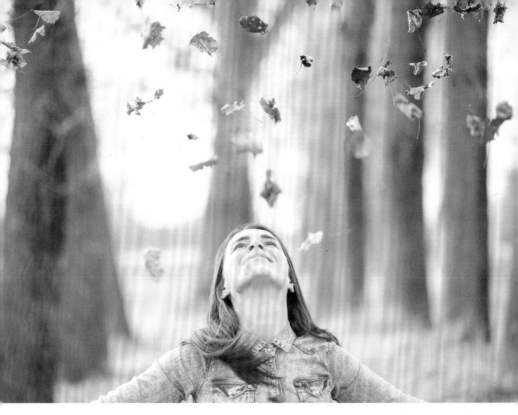

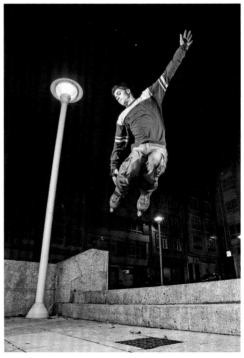

ABOVE: Your camera's built-in flash isn't the most powerful or flexible option, but it can come in useful outdoors as a fill light, to brighten any shadows falling on your subject.

RIGHT: Shooting when the light levels are low and freezing action are two of the most common uses for flash. However, don't expect your camera's built-in flash to excel in this type of situation: a more powerful flash will be needed, ideally used separately from the camera.

Exposure

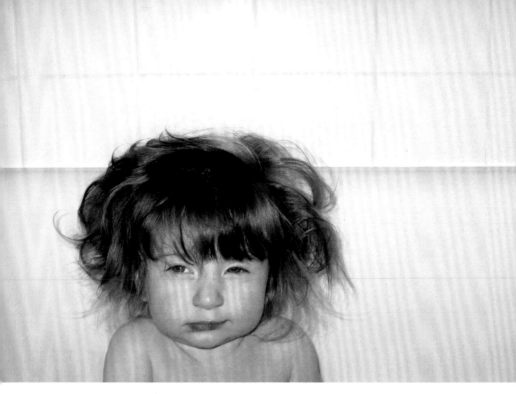

ABOVE: Your built-in flash is small, weak, and direct—a combination that will never deliver the best results. However, it's better than nothing in certain situations, and as it's built in to your camera, there's no reason why you couldn't shoot a scene with and without flash to see if it improves things (or not).

TOP: Built-in flash is handy when you want to quickly add light, but you need to be aware of its limitations: the low power means your subject needs to be relatively close to the camera, and red-eye (as seen here) is always a risk.

KNOW YOUR LIMITS

About the nicest-thing you can say about the flash built into your DSLR, CSC, compact camera, or cellphone is that it's better than nothing—at least it is when you let Auto mode take control.

For low-light photography, built-in flash is usually far from ideal, which might sound like a strange thing to say considering flash is the obvious go-to solution when you're shooting indoors or at night (and Auto will happily fire it off with alarming regularity). The problem is, built-in flashes are small and weak, close to the lens, and they point directly at your subject—all of which will conspire to ruin your low-light ambitions.

First up, you need to make sure that your subject isn't too far from the camera so that the light from the (weak) flash can reach it. But the closer your subject is, the more quickly your shots will suffer from "flash fall-off," resulting in that obvious lit-by-flash look where the subject is brightly lit, but the background is plunged into darkness. This happens because the intensity of light decreases more quickly the closer it is to the camera (the far more technical reason is based on the "Inverse Square Law," but we're not going there today).

Also, because the flash is so close to the lens (and is aimed directly at your subject), there's an increased risk of red-eye as light bounces off the back of your subjects' eyes. We'll explore workarounds for low-light shooting on page 72.

Your built-in flash is a little more helpful during the day, when you can use it outdoors as a fill light to brighten up dark shadows. This is especially true when you're photographing people, although that weak power can be problematic on very bright days. Again, we'll look at this in more detail on page 76.

ADVANCED TTL

Flash is a vaaaaaast subject, so we're going to stick to the designed-for-digital advanced TTL systems here, which is the default flash control mode on your camera (E-TTL II for Canon users, iTTL on your Nikon, and P-TTL with a Pentax). The TTL part of it stands for "through the lens," which means the system automatically controls the flash exposure based on the actual amount of light coming through the lens.

While each manufacturer has its own version of TTL flash, it's a bit like multi-area metering—different names for systems that broadly do the same thing. If you watched the process in slow motion it would go something like this: You press the shutter button to take a shot…the flash fires a weak "pre-flash"…the pre-flash bounces off your subject… this reflected light enters through the camera's lens…the camera measures the light coming through the lens…the camera determines how much flash is actually needed for the exposure (based on the weak pre-flash)…the camera fires the flash a second time at the adjusted level…this time around the shutter opens to make the exposure.

What's most remarkable about all that is that it happens in a split second—so fast, in fact, that you only "see" one burst of flash, and (usually) end up with a perfectly exposed, flash-lit subject. When you think about it, that's really pretty incredible.

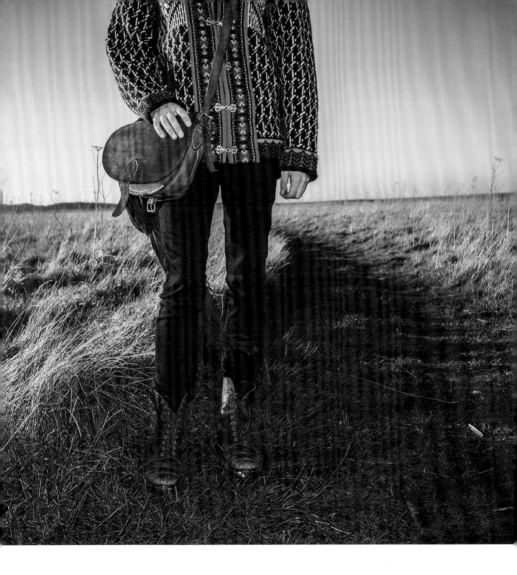

ABOVE: Mixing flash with daylight used to be something of a dark art, involving guide numbers, distance tables, and some fairly tedious math. But TTL flash has changed all that—it's one occasion when letting your camera make the decisions is not necessarily a bad thing.

FLASH EXPOSURE COMPENSATION

As smart as advanced TTL is, it suffers the same curse as your camera's regular metering modes—it still wants to give you that "mid-gray average" we talked about on page 54, no matter what. So if you've got a bright subject reflecting lots of light or a dark subject absorbing your flash, the camera's going to try and fix it for you, which is probably going to result in an unimpressively dull shot.

To fix this, you need to find your camera's flash exposure compensation control (this is often the same button you use to pop up your flash, or it might be on the flash itself if you're using an external unit). Flash exposure compensation works in the same way as regular exposure compensation (skip back to page 62 for a refresher), but it only affects the flash part of the exposure, allowing you to pump up the flash a little when you want to keep those bright subjects sparkling, or knock the exposure back to darken down those shadier shots.

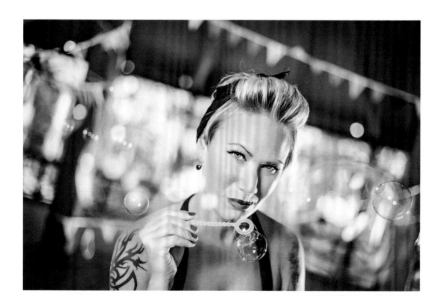

ABOVE: Flash compensation is your number one tool when it comes to balancing the output of a flash (on camera or off camera) with the available light. Used subtly, it can lift your subject, without becoming overpowering, as is the case with this portrait.

OPPOSITE: Alternatively, flash compensation can be used more obviously. For example, increasing the power of the flash, while decreasing the exposure for the ambient light, makes the flash become the dominant light source, typically resulting in dark and moody backgrounds.

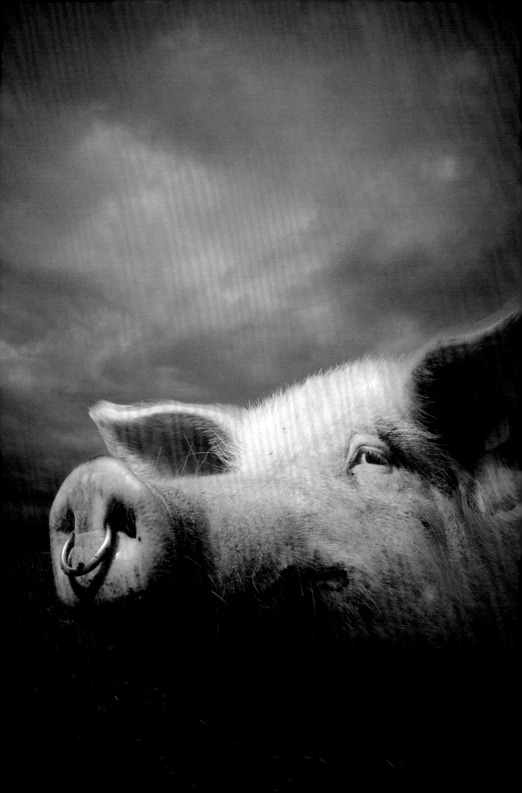

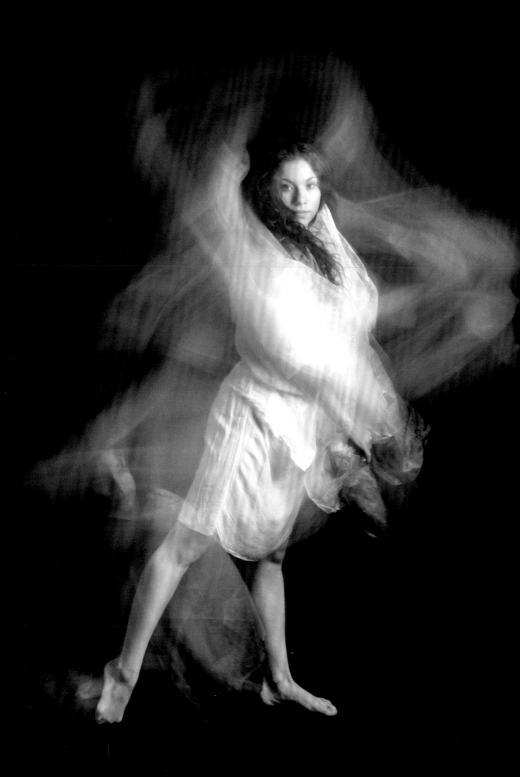

GETTING LOW LIGHT RIGHT

Because you need light to make an exposure, the most obvious use for flash is to "create" light when it would otherwise be too dark to shoot: indoors, at night, shooting in a cave, or any other low-light situation you care to choose. However, for the reasons given on page 66, your built-in flash isn't going to give you the best results if you just blast away with it. But this can be resolved quite easily with just three key changes:

Red-eye reduction: If you're photographing people in low-light conditions, red-eye reduction is a must. It's not perfect (hence red-eye reduction, not prevention), but it will help minimize those glowing red "devil eyes" in your shots. It can also be used to reduce "green eye" when you photograph animals in the same conditions.

Flash sync: Flash sync (synchronization) lets you combine slow shutter speeds with flash so you can use a brief burst of flash to light your subject and an extended exposure time to light the (non-flash-lit) background. Some cameras set flash sync by default, but others need you to activate it yourself. Either way, it will help prevent those bright subject/black background night shots, so make sure it's switched on.

You might have to go hunting in the menus, but somewhere on your camera will be the option to choose 1st-curtain or 2nd-curtain flash sync (also sometimes called "front" and "rear" sync). What this does is determine when the flash fires: at the start of an exposure (1st/front sync), or at the end (2nd/rear sync). Both have their advantages, but 2nd (rear) curtain sync gives more natural results whenever there's a chance of subject movement.

OPPOSITE: Flash sync (2nd-curtain, in this case) lets you combine the motion-freezing power of flash with a blur-inducing shutter speed, giving you a strong sense of movement, but without your image becoming an unreadable "smear."

FILL IT IN

When you're starting out, using flash outdoors—while it's light—can seem like a strange decision to make, but a lot of times "fill flash" can make a huge improvement to your shots. The classic example here is on a sunny day when harsh shadows are cast across your subject, especially when they are backlit. However, all you need to do to fix this is activate the flash (usually by popping up or pressing a "flash on" button). Your camera's TTL control will kick in to balance the flash with the daylight and fill in the shadows— it's that simple!

This won't be particularly subtle, though, and the result is likely to have an obvious "lit by flash" look about it. Again, this is an easy fix. To create a more sophisticated fill, just set the flash exposure compensation to -1/2 or -2/3. This will be enough to lift the shadows, but not so much that the result looks artificial—as seen in the "soft" portrait below.

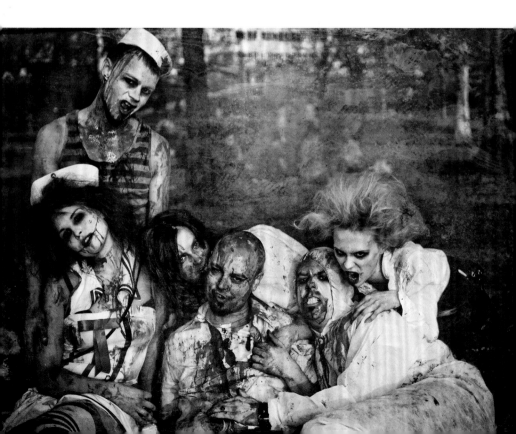

Alternatively, you can go in the opposite direction and produce a more radical daylight flash effect that definitely isn't subtle or natural. Reducing the regular exposure (using negative or minus exposure compensation) will darken down the overall exposure of your shot, but increasing the flash exposure (using + flash exposure compensation) by the same amount will ensure your subject remains perfectly lit. The result is a darkened background and an obviously flash-lit subject.

Taken to extremes, the latter option can start to turn day into night, making the background in your shots less distracting and your subjects really "pop." It is best done on an overcast day when the light levels are low, though—on a bright day your camera's built-in flash may simply not be powerful enough to "overwhelm" the daylight.

OPPOSITE: For this group portrait, taken during the Zombiewalk VI "Rotten Rampage" event in Helsinki, Finland, photographer Marko Saari used a Nikon Speedlight SB-800 with a Ray Flash ring flash adaptor to give subtle fill flash. Isolating the undead group from its background meant using a wide aperture (f/2.2), which resulted in a fast, 1/1000 second shutter speed. In this situation, high-speed flash is essential, but not all flash units have this feature—if fill flash in bright daylight is your aim, then it's worth checking before you buy.

RIGHT: For his ongoing series of environmental studies, *Terra Incognita*, artist and lecturer Grant Rogers uses the built-in flash on his Leica Digilux 2 camera to produce a theatrical "day for night" effect. Setting the aperture to f/8–f/11 and the shutter speed between 1/500 second and 1/2000 second (in Manual mode) will effectively underexpose the scene in all but the brightest of sunlight. However, the camera's small, built-in flash is used to illuminate the foreground detail and create definition in the middle ground. As the photographer says, "One of the greatest feelings of confidence came for me when I switched my camera from A to M. I no longer felt that I was *taking* pictures but that I was *making* them."

BOUNCE, SWIVEL, & OTHER HOT-SHOE OPTIONS

If you find yourself regularly wanting or needing to use flash, then you'll also find yourself bumping up against the limitations of your camera's built-in unit more often than you'd like. For most would-be strobists, this makes an external flash unit the next item on their photographic shopping list. There are plenty of external flash units available that will slide into the hot shoe on top of your camera, from both the company that made your camera and third-party alternatives (at less eye-watering prices). However, you need to make sure that what you buy now is still the flash unit you want in 12 months' time: expensive mistakes are easy to make.

Guide number: Every flash has a "guide number," which can be used as a rough guide to its power: the higher the guide number, the more powerful the flash. Be careful though, as not all measurements are equal. Some manufacturers quote the guide number at ISO 200 (rather than ISO 100) or use different focal lengths to "massage" the numbers and make a flash seem more powerful than it actually is.

TTL: If you want to continue using your camera's advanced TTL flash control you need to make sure the flash you choose is dedicated to your camera system. It's worth noting that every manufacturer's flash-control system will evolve over time, so yesterday's flashes might not always be fully compatible with today's cameras (and vice versa). Third-party flashes are not always 100% compatible either, so do your homework first.

Bounce: An external flash unit with a bounce head lets you angle the flash upward, so you can bounce it off a ceiling or reflector board. The benefit of this is the light from the flash is no longer direct, which removes any chance of red-eye and also creates a softer, more pleasant light. If you're investing in an external flash unit, this is definitely a feature to have.

Swivel: As well as letting you bounce the light from the flash, some flash units let you swivel the head for even greater versatility. If the flash offers TTL control then the camera will automatically take this into account when it makes an exposure.

Auto zoom: A flash with an auto zoom head will automatically match the coverage of the flash to the focal length of the lens you are using. This means that the pool of light from the flash will closely match the frame area of your photograph, so you're getting the optimum flash coverage (and power) with each and every shot.

High-speed flash: Allows you to use very fast shutter speeds with flash. This is not essential, but it is useful when you want your flash to show on a very bright day.

Manual: If your flash has a manual mode, you can set its power yourself rather than relying on the camera's TTL control. This is most useful if you want to use the flash off-camera in a studio-style setup, and is the mode of choice for hardcore strobists (especially as older, non-dedicated flashes with a manual mode are relatively inexpensive).

BELOW: A proper flash unit offers plenty of controls to fine-tune the manual flash output. But even if you leave it all to automatic TTL control, you should still consider whether swiveling or tilting the head in a particular direction will cast a more desirable light on your subject.

Wireless: If your flash (and camera) offers wireless control, you can combine the versatility and creativity of using flash away from the camera with the ease-of-use of advanced TTL. It's not a cheap option, but it's the path to some truly stunning location shots, especially if you start experimenting with multi-flash setups.

03
FOCUS

LOOKING SHARP

It wasn't that long ago that if you wanted a sharp photograph you had to manually turn a lens to focus it. Then autofocus—or AF—hit the scene, replacing manual effort with electronic motors that buzzed and whirred, shifting the lens elements to give us a sharp picture. However, those early AF systems were fairly primitive beasts, to the point that manually cranking the lens was often a quicker, quieter, and more accurate option. But that was then. Fast-forward to today and the focusing landscape has changed dramatically. Now, we can raise our camera, press the shutter-release button, and near-silent motors snap our lenses into focus in double-quick time.

Unfortunately, with your mode dial set to Auto, your camera gets to choose *where* to focus, and also *how* it will use your camera's AF system—your AF may be quick and accurate, but that's little use if the camera's not picking the right target. And sadly, focus is one area where Auto mode can really start to struggle. This is because focus can be something of a subjective decision. Take a landscape, for example. You could be including several miles in a single frame, from flowers in the foreground to mountains in the distance, but which part of it is most important? Similarly, let's say you're filling the frame with your nearest and dearest (boyfriend, girlfriend, spouse, or that flea-bitten kitty that hangs out on your bed). Do you want to focus on their eyes, their nose, or the tips of their ears? You know the answer, but does your camera? Of course not—it's going to have to guess.

OPPOSITE: You can do a lot of things to an image "after the event" (this shot was run through Photoshop, DxO Optics Pro, and CameraBag 2), but the one thing you can't change is the focus.

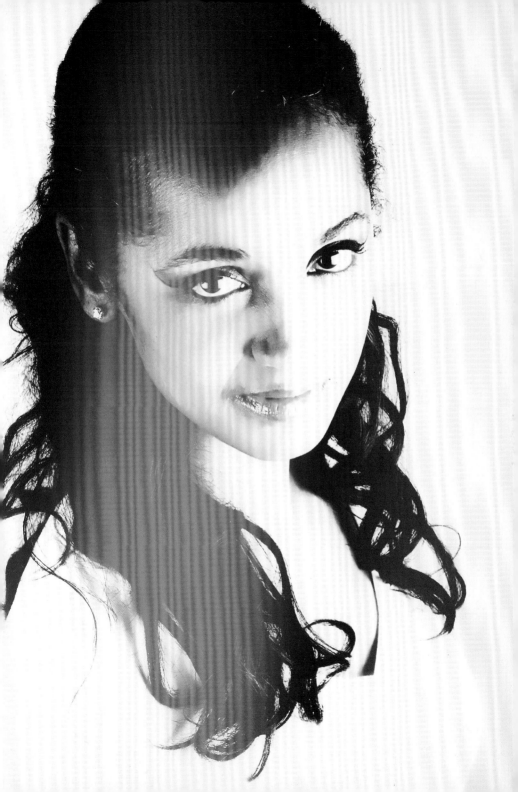

If your camera's got some sort of "face-detection" system and you're photographing a person, then it will probably do a pretty good job here, but with most other things it will decide for itself. Usually, this means it will employ whichever of the multiple AF points it feels are needed to focus on whatever it sees as the subject. This decision will typically be based on proximity and contrast, so it will focus on the closest, most contrasty point—the "obvious" part of your shot (because your subject is going to be obvious, right?).

The camera may come up with the right focusing answer, resulting in a sharp shot, but if there are multiple points that it likes the look of (or no points that it finds obvious) then things become more "interesting." With two equally appealing points, it could pick either one, or it might try and focus somewhere between the two; with no obvious focus point, your camera might simply refuse to take a shot. Either way, if the camera gets it wrong there's nothing you can do, so it's time once again to move beyond your camera's Auto mode.

OPPOSITE: If there's strong contrast between the main element of your shot and its background, and the precise point of focus is relatively unimportant, then you could allow your camera to choose the AF point. In this shot, it did the job.

ABOVE & RIGHT: Faced with this scene and a free hand over the AF point, the camera chose to focus on the higher-contrast tree trunks at the left of the frame.

AUTO OPTIONS

Autofocus has some pretty obvious advantages, but the key to getting the best from it starts with understanding two core concepts: AF points and AF modes.

AF points are the black dots, squares, or rectangles that you see through your camera's viewfinder (the ones that light up when you try and focus on something, usually accompanied by an irritating "beep"). Each of these points corresponds to a sensor in your camera that can be used to "identify" your subject and focus on it. Usually, you can either allow the camera to choose the appropriate AF point(s) for you (which is typically how Auto mode uses your camera's AF), or pick a focus point yourself. This is by far the better option, because you are telling the camera what you want it to focus on.

Now, when you go to a camera store, a good sales guy (or girl) should tell you that the more AF points a camera has—and the more of the frame they cover—the "better" that camera's AF system will be. This is sound advice, because more points, spread wider across the frame, means that more individual parts of the scene you are photographing can potentially be targeted.

Canon T5/EOS 1200D

Canon EOS 7D Mark II

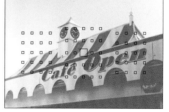

Nikon D7100

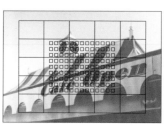

Nikon D810

Sony A7II

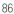

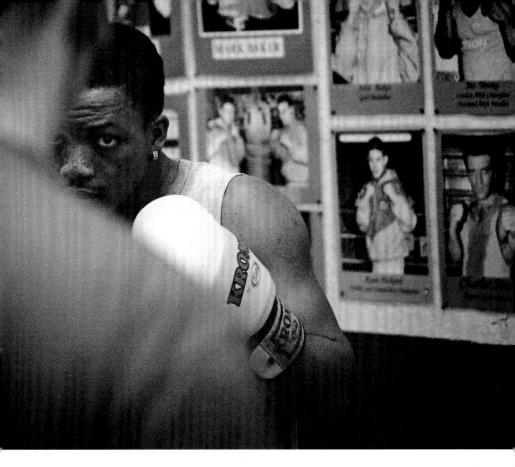

ABOVE: There are plenty of elements in this scene that the camera might have chosen to focus on if it had been left to its own devices in Auto mode. However, I couldn't risk "missing" a shot, so chose the AF point myself.

OPPOSITE: The number of AF points and the way in which they are arranged across the frame varies wildly from camera to camera.

Focus

Of course, sometimes there won't be a conveniently placed focus point sitting right over your subject, but don't let this deter you. For a start, the AF points away from the center are less sensitive, so unless there's plenty of light, you're using a wide aperture, and/or the target area is quite contrasty, there's no guarantee those edge points will get a lock quickly or accurately, even if they are neatly on top of your subject.

Indeed, for a lot of shooting situations you might find that you can just use the AF point that's slap bang in the middle of the frame. This is the most sensitive AF point on your camera, so it typically snaps the lens into focus quicker and more accurately than the rest.

It also means there's no need to fumble around trying to select a different focus point. Sure, this doesn't take long on most cameras, but it's often a lot quicker to aim the camera straight at your subject, press the shutter-release button down halfway to focus, and then keep the button held halfway while you reframe the shot—it takes longer to read it than it does to do it, trust me. Working like this also means you can put your subject anywhere you want in the frame, whether that's dead center, to one side, or even tucked away in the corner.

However, this only works in single shot AF and if your subject stays the same distance from the camera—in the split second it takes to reframe your shot, a moving subject is almost certainly not going to be in focus any more. It's also inadvisable if you're shooting close to your subject with a super-shallow depth of field, again because slight camera movement can result in the focus "missing" slightly when you reframe. The rest of the time, though, it's a system that works well—try it for yourself.

OPPOSITE TOP & BOTTOM: It is often quicker to use the central AF point, lock focus, and reframe your shot, rather than scrolling through multiple AF points to find the most suitable one. However, on most cameras the exposure is locked along with the focus, which can lead to exposure issues with scenes like this one. To avoid this, check your camera's custom functions for an option that lets you set the AF-L (focus lock) button to "focus only."

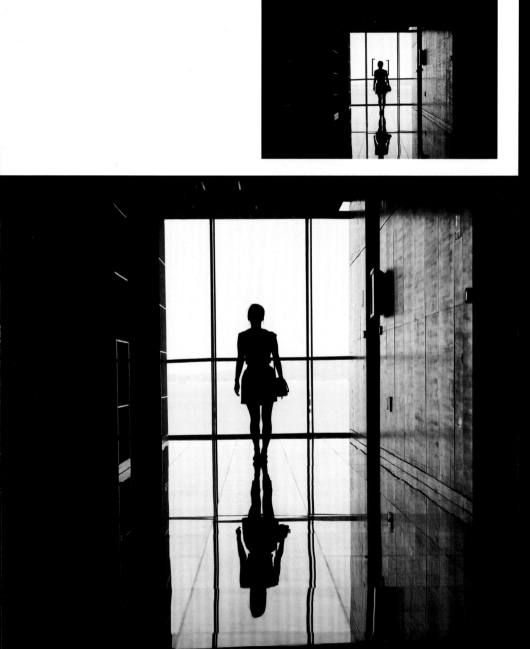

AF MODES

While AF points are used to determine *where* the camera focuses, AF modes tell it *how* to focus. There are various names used by camera manufacturers to describe their particular modes, but they are all generally using derivations of the same three technologies: single shot, continuous, and auto AF.

Single-shot AF

Also referred to as One-Shot AF (Canon) and AF-S (Nikon), your camera's single-shot AF mode is designed to set the focus when you press the shutter-release button down halfway. The lens will stay set at that focus distance until you either press the shutter-release button down fully to take a shot, or you lift your finger off it. This is the ideal mode for anything that isn't moving.

Continuous AF

Canon calls it AI Servo AF and Nikon calls it AF-C, but they're both talking about the same thing—continuous focus. In this mode, pressing the shutter-release button down halfway starts your camera focusing, but focus doesn't stay set at a single distance. Instead, once it's got a lock on your subject, the camera will try to maintain focus by continuously adjusting the lens as your subject moves. As this suggests, continuous AF is your go-to mode for (almost) all things moving.

In addition to adjusting the focus constantly, a lot of cameras use "focus tracking" and "predictive AF" in conjunction with continuous AF. These technologies help the camera to predict where a moving subject is heading (and how quickly) and then switch AF points if it needs to, so that your subject is tracked across and around the frame, with the focus constantly adjusting to keep it sharp.

ABOVE: Will it or won't it? Sometimes you just can't tell if your subject is going to make a break for it or stand stock still while you shoot. If in doubt, Auto AF can help.

RIGHT: If you're certain your subject isn't going to move (this building wasn't going anywhere) then single shot AF is ideal. The color came courtesy of CameraBag 2's "Hawaii" filter effect.

Focus

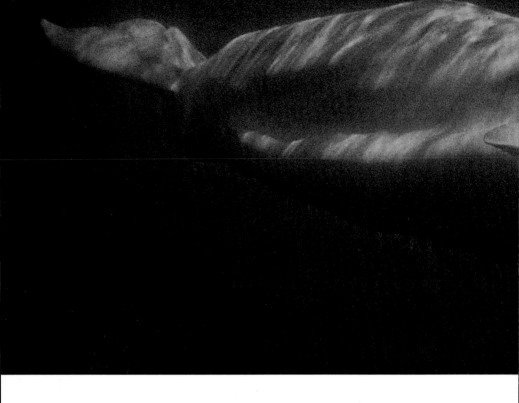

ABOVE: Some subjects move, and you'll know they will. Continuous AF encourages your camera to maintain focus as your target races (or, as in this case, glides) across or around the frame.

Auto AF

If you're shooting with a Canon camera, you'll find this mode's called AI Focus AF; on your Nikon it's AF-A. In both instances, the mode in question is "automatic autofocus." Switch to this and focusing starts in single shot mode. However, if the camera detects any movement it will switch to continuous focus and try to follow your subject. This is usually the default AF setting when you shoot in Auto mode, and it does have its advantages if you're not sure whether your subject is about to take off or not. Mostly, though, choosing single-shot AF when you know your subject's not going anywhere, or continuous AF when you know it is, will usually provide you with a smoother ride— sometimes, Auto AF just gets it wrong.

MANUAL FOCUS IN DETAIL

While the AF systems in most of today's cameras will do a phenomenal job of snapping your photographs quickly and accurately into focus, there are times when switching to manual is a better option. This is usually for one of two reasons: accuracy or speed (yes, manual focus can be faster!).

When it comes to focusing accurately, your camera's AF system will typically use contrast to identify an "edge" to lock on to. For most subjects this isn't a problem, but if you try to photograph a subject that's largely the same color (or subtle shades of the same color); if you want to photograph something composed of several "layers" and focus on a specific one; or if you're shooting in fog or mist, or low light (when the contrast is naturally low), your lens might start "hunting." This is the annoying moment when a lens starts shifting focus backward and forward, without actually locking. However, rather than letting your lens buzz futilely (draining your camera battery as it does so), simply switch to manual focus and turn the focus ring—it's almost certain to get your focus precisely where you want it.

Despite its technological prowess, your AF can also struggle with very fast-moving subjects, such as racing cars and that kind of thing. The problem here is your camera's AF just isn't quick enough to identify and target your subject before it zooms out of shot. As strange as it might sound, focusing manually in this situation can be much *faster*. How? Because you can *prefocus*. If your subject's on a track, pick the point where you want to photograph it, switch to manual focus, and turn the focus ring to snap that track section into focus. Alternatively, set the focus at infinity (maximum distance) if you know your subject's going to be a long way off (photographing fighter jets or stunt planes at an air show, perhaps). Now, you just need to time your shots for when your subject enters the frame—your focusing is already taken care of.

TOP: Getting a sharp result is often the name of the game, but it doesn't always have to be that way. This beautifully minimal, abstract urban landscape was created by deliberately *defocusing* the lens—and that meant switching to manual focus.

BOTTOM: This uber-fast subject will almost certainly be at infinity in terms of focus distance. If you focus manually at that distance, you can shoot safe in the knowledge that focusing is taken care of for each and every subsequent shot.

NOT ALL LENSES ARE EQUAL

With the exception of camera phones and some low-end compacts, almost every camera will let you set the focus manually, but that's not the same as letting you set it easily. With a DSLR or CSC this comes down to the design of the lens, and it's fair to say that there are some really poor lenses out there, which switch from their minimum to maximum focus distance with an impossibly small turn of a tiny focus ring. As a general rule, low-cost zoom lenses (especially "kit" lenses) are the worst offenders.

The best manual focus lenses are those with wider focus rings (allowing a better grip), which turn through a much greater distance from minimum to maximum distance (offering much greater precision). A lens that offers slight resistance when you turn the focus ring will also allow you to focus more accurately. Prime (fixed-focal-length) lenses are usually best in this regard, and if you have the opportunity, get hands-on with a quality manual-focus lens from a 35mm film SLR—that's the exact feel you want.

In fact, if you want to go down the manual focus route, older prime lenses can often be a great option (unless you're shooting with a Canon DSLR, in which case those lovely old F-mount lenses won't fit your EOS camera). The reason for this is obvious: those early lenses were designed specifically for manual focus, with well-preserved examples offering smooth focusing, wide maximum apertures (for gorgeous shallow depth of field effects), and distance and depth-of-field scales to help you on your way. Sure, you might not be able to use some of your camera's automated (and possibly semi-automated) shooting modes, but you can usually still shoot using Aperture priority and Manual.

OPPOSITE TOP: Don't rule out using "old-school" manual focus lenses on a digital camera—there are some great lenses out there. You can add to the retro vibe by using various apps to recreate vignetting, film grain, or even light leaks. I used CameraBag2 to get this vintage look.

OPPOSITE BOTTOM: Nikon's 35mm $f/1.8$ prime lens (left) has a wide focus ring with a "positive" feel, whereas the company's 18–55mm $f/3.5$–5.6 "kit" zoom (far left) relies on a tiny plastic ring at the front of the lens. Both lenses can produce great results, but only the prime lens makes focusing manually a pleasure.

CONFIRMATION

Whether you turn to manual focus through choice or necessity, there are two features that can help to guarantee that your focus is spot-on, rather than "almost there."

The first of these is your camera's focus-confirmation indicator. This is usually displayed as a solid circle in the viewfinder display, which illuminates when the camera thinks your subject is in focus. Although this is most commonly associated with getting a "lock" when you're using AF, it also works when you switch to manual focus, with the indicator lighting up when the camera senses that the area under the central focus point is in focus (even though the central focus point isn't actually being used to focus with). However, although the focus indicator is useful, it relies on the same sensor used by the camera's AF, so it can struggle under low-contrast conditions or with layered subjects.

An alternative (and arguably more accurate focus aid) is Live View, which enables you to frame your shots using the rear LCD screen. What is most useful is the option to zoom into the preview image, which makes focusing manually far easier than it is when you're peering through a diminutive viewfinder. Most cameras will also allow you to move the preview area around the frame for even greater accuracy.

A word of warning, though: do not zoom in too far. Although it's tempting to magnify the image by the maximum amount, this will leave you looking at pixels rather than detail. Instead, zoom in fully and then back out by two magnification "steps." On most cameras, this provides the perfect balance between image magnification and detail.

LEFT: When I'm shooting in a studio-style environment, with the camera on a tripod, I'll often hook my camera up to a laptop and shoot "tethered." Part of this process means I can focus manually, using the on-screen preview and in-camera focus confirmation as guides. This is especially helpful when shooting close-up images, as the depth of field reduces dramatically, which can easily result in "missed" focus.

IS, VR, & ANTI-SHAKE DOODAHS

As soon as the pioneers of photography liberated their cameras from studio stands and tripods and started shooting handheld, "camera shake" became a very real problem. Shooting handheld undoubtedly gives you greater freedom and allows you to shoot more spontaneously; it's also the cause of countless blurred and fuzzy shots.

The obvious solution is to lock the camera back down on a tripod, so it's sitting on a rock-solid support. You still need to take a little bit of care when you shoot (using a remote release or the camera's self-timer so you don't knock the camera when you trigger the shutter), but for 99% of your exposures camera shake will no longer be the cause of soft shots.

However, tripods are slow and cumbersome, and you've got to haul it around with you to start with. It's great when you're shooting in a studio, or want to wait for the "perfect" light for your landscape studies, but for candid shots, action shots, or any other shot that might benefit from a more "freehand" approach, a tripod will only hold you back.

So, first off, if you want to handhold your camera you need to do it right. Shooting one handed with your camera at arm's length might make you look like a cool and casual snapper when you're using Auto, but it's also going to increase your chances of a blurred result (and not all blurred shots count as "arty"). Instead, you need to take your camera in both hands. While the exact grip will depend on your camera, for most DSLRs (and DSLR-styled CSCs) it's the same advice that Grandpa was given over 40 years ago when he was shooting with his Contaflex, Nikkormat, Spotmatic, or other early SLR of choice.

ABOVE: In the past, shooting handheld in low-light conditions with a long and heavy telephoto lens could easily lead to camera shake. However, thanks to sensor-shift and lens-based image stabilization systems, that's now much less of a problem.

Your right hand curls around the side of the camera, with your index finger hovering by the shutter release (and top controls) and your thumb ready to rove across the buttons and dials on the back. Meanwhile, your left hand supports the camera underneath, with your thumb and index finger at the ready on the lens' zoom ring (or focus ring). Then it's a case of elbows tucked in to your sides (not flapping around like chicken wings); feet shoulder-width apart (if standing); camera to your eye (assuming you've got a viewfinder!); and then trigger the shutter on an out breath.

Straight away, that will give you a solid and stable "shooting platform," but it will also help if you set your shutter speed so that the big number on the fraction is equal to or higher than the focal length of your lens. That means setting 1/100 second or faster with a 100mm focal length, no slower than 1/200 second with a 200mm lens, and so on.

If you combine the perfect stance with the ideal shutter speed, you will maximize your chances of a sharp result, but you still have something else on your side that Grandpa didn't have on his retro SLR—21st century technology. Today, when you handhold your camera, anti-shake is your greatest ally.

The technology behind "shake-reduction" has been evolving for over a decade now, although opinion is still split over the best approach. Some manufacturers favor lens-based stabilization, which typically relies on a system of sensors and "floating elements" in the lens to counter any camera shake, while others use sensor-shift systems that move the sensor to compensate for any unwanted tremors. The arguments for each are laid out in the grid opposite, but the bottom line is this: if you're handholding your camera, either option is better than nothing.

	For	Against	Used by
Lense-based stabilization	Stabilization optimized for the specific lens/focal length.	Stabilized lenses are often more expensive.	Canon: Image Stabilization (IS)
			Nikon: Vibration Reduction (VR)
			Panasonic: Power Optical Image Stabilization (Power O.I.S.)
	Stabilization effect can be seen through the viewfinder.	Not all lenses are stabilized (or have a stabilized option).	Sigma: Optical Stabilization (OS)
			Sony: Optical SteadyShot (OS)
	Stabilization aids AF system in low light.		Tamron: Vibration Compensation (VC)
Sensor-shift stabilization	Stabilization available to any lens attached to the camera.	A "catch-all" solution that works equally well for every lens (however, telephoto focal lengths are affected more by shake than wide-angles).	Pentax: Shake Reduction (SR)
			Sony: SteadyShot
			Olympus: Five-axis image stablization

04
COLOR

IT'S NOT ALL WHITE

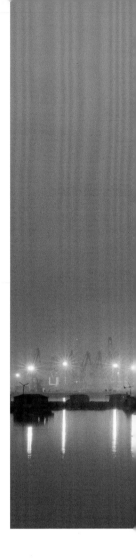

When we look at the world around us, white is pretty much always white, and the rest of the colors fall into place accordingly (green grass, blue skies, and all the rest of creation). If we carried a sheet of plain white paper around with us, then it wouldn't matter whether we were indoors or out, under fluorescent lighting or a clear sky post-sunset—that sheet of paper will look white.

However, the color of the light around us is anything but constant: the bulbs in our houses are usually a warm orange; daylight is a cooler blue; and that nasty fluorescent light flickering above our office cubicle is likely to be some sort of sickly green shade. The reason we don't usually notice this too much is because our eyes and brain—our "human visual system"—are working together to make sure that white stays consistently white (or as close as humanly possible). If it didn't do this, then we would find ourselves living in an almost constantly changing kaleidoscope of color—the outdoor world would be a shade of blue; we would live in hot, orange houses; and we would wake in the morning eager to get to our bilious green offices…

Yet that's exactly how your camera sees the world. Your camera's sensor isn't "smart" like your eyes and brain—it has one fixed response to the color of light. Consequently, it needs a little bit of technological know-how to help ensure that your whites stay white, which is where "white balance" comes in. As you will see in this chapter, white balance (WB) is a crucial photographic tool—not only for "neutralizing" the colors of the world around us, but also for exploiting them for creative effect.

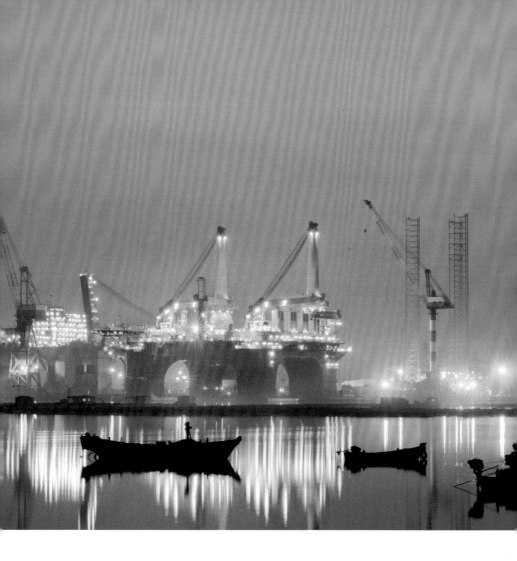

ABOVE: This shot is a clear example of different color temperatures at work: in addition to the cool blue of the post-sunset sky, there is warm orange and white/green artificial lighting as well.

ABOVE: Auto white balance can work well when your scene is lit by a single, readily identifiable light source, but faced with a cacophony of colors like this, you might find it can struggle to produce the result you want.

A QUESTION OF BALANCE

Each of the many and varied light sources you encounter has what is known as a "color temperature," which is measured in degrees Kelvin (K). The color temperature scale encountered in photography typically ranges from around 2000K (the very warm orange glow of candlelight), through to 10,000K (a clear deep-blue sky). Between these extremes lie the light found in open shade and on overcast days (around 6500–8000K, toward the blue end of the scale); domestic incandescent lighting (around 3000K, at the warm end of the scale); "average daylight," which has a temperature of 5500K and is considered "neutral"; and a host of light sources in between.

By far the easiest way of dealing with the various color temperatures you will encounter is to set your camera's white balance to Auto and leave it to try and deal with everything you throw at it.

If you're shooting under a single, constant light source (outdoors in a shaded street, for example, or indoors under tungsten bulbs) then your camera's Auto white balance will usually do a great job because it is only being asked to identify and balance a single color temperature. However, it's not a perfect system, and like all automated camera functions it relies on the camera making some fairly fundamental choices. And, as we've already seen, when your camera calls the shots, it doesn't always give you what you want.

ABOVE LEFT & RIGHT: When a single color dominates a scene, your camera's Auto white balance can overcompensate. That's what happened with this weld-based artwork: Auto white balance (above right) has tried to "correct" the rusty reds, resulting in an overly cyan/blue image. As you will see on the following pages, when you think this might happen, a preset white balance can help. Here, I set the white balance to "Daylight" for a more accurate rendering (above left).

WHEN THINGS GO WRONG

There are numerous ways in which your camera's Auto white balance can give you a disappointing result, and the first of these is—somewhat ironically—because it can do its job too efficiently.

Take a sunset, for example. You might see a beautiful range of fiery oranges, yellows, and reds burning across the sky, which you just know will make a spectacular print for your living room wall, but your camera's Auto white balance simply sees a scene that is too warm. Consequently, your camera will cool the shot down with ruthless efficiency, neutralizing the color bias and—in the process—killing that apocalyptic sky you wanted so badly as wall art. And it's not just sunsets that your camera has no feeling for: it's any scene containing a single dominant color, as shown opposite.

Your camera's Auto white balance also doesn't like it if you start mixing light sources, because then it has to decide which one is most important. Let's say you're taking a shot of someone sitting outside a café at dusk. In this fictional scenario, the sky is a beautiful clear blue (a high color temperature), but the lighting inside the café is incandescent (a low color temperature), which is throwing a warm orange glow onto your subject. Now, in a split second, your camera has to decide which of these color temperatures is most important—the cool blue daylight, or the warm orange tungsten lighting—and then set the white balance accordingly.

Depending on the programming behind its decision-making processes it might decide to set the ambient light as "neutral" (which would make the tungsten lighting appear even more orange); it might go with the tungsten light (making that blue daylight bluer still); or it might set something in between (which would result in a distinct blue/orange split). None of these choices is wrong, but that doesn't mean any are right, either.

PICK A PRESET

Because the camera manufacturers know you want more from your camera than a brainless point-and-shoot experience, they've equipped it with a selection of "preset" white-balance options for you to choose from. These presets are based on the color temperature of a handful of frequently encountered light sources: the grid below shows the full range of presets, their relevant color temperatures, and the icon to look for when you want to make that change.

Conventional advice is simple: pick the white-balance preset that matches the prevailing conditions (so when you find yourself shooting outdoors on a cloudy day, set the Cloudy white-balance preset; when you're shooting outdoors on a clear day set Daylight; you get the idea). This is a perfectly sensible recommendation, and most of the time it will give you a good result. However, what needs to be added is that presets are a very simple solution that—I hate to say it—are still going to be wrong more often than they are right.

This is because your white-balance presets are, by their very nature "pre set." Each option is programmed to "correct" a specific color temperature, be it Daylight (which is usually

White Balance Setting	Icon	Typical Color Temperature*
Daylight	☀	5500K
Cloudy	☁	6000K
Shade	🏠	8000K
Flash	⚡	5500K
Incandescent (Tungsten)	💡	3200K
Flourescent	💡	4500K

* The precise color temperature assigned to each preset will vary depending on the make and model of your camera.

set at 5200K or 5500K), Incandescent (which could be 3000K, 3200K, or 3300K, depending on your camera), or any of the other options. Unfortunately, light doesn't obligingly stick to these values. Over the course of a day, the color temperature of daylight will shift from the warmth of sunrise, through cool midday skies, and then grow warmer again as sunset approaches. Throw in light, heavy, and thick clouds (each of which will affect the color temperature differently), and it's easy to see that you'll be very lucky if the temperature of the light matches your Daylight and Cloudy presets.

So, while presets will get you close to a color-correct result, they are not the definitive solution that many people would have you believe. Auto—with its variable response—can sometimes be the better option.

BELOW: Your camera's white-balance presets might not be 100% accurate, but they can often get you near enough to the right result. This is most easily done when there's a single light source—when there's more than one light source (as was the case with this office building), it's up to you to determine which preset is most appropriate. With a shot like this, setting the white balance for the daylight (via the Daylight white-balance preset) and allowing the artificial lighting to appear colored is usually the best option.

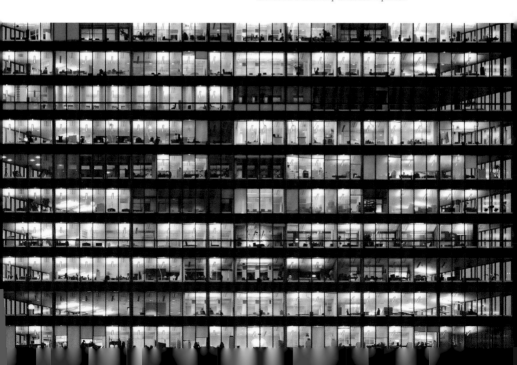

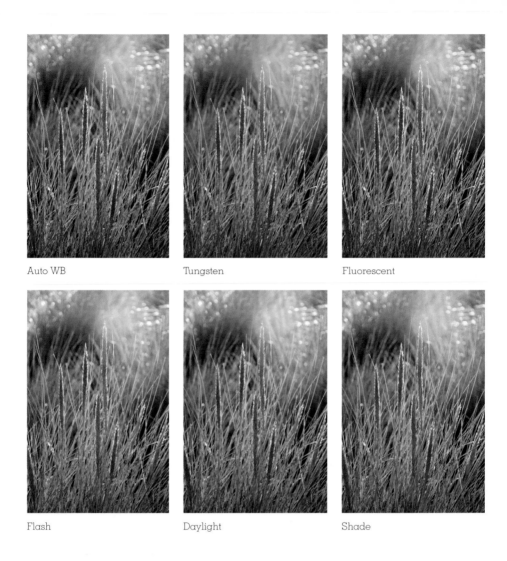

Auto WB

Tungsten

Fluorescent

Flash

Daylight

Shade

ABOVE & OPPOSITE: I photographed these grasses just after sunrise on a summer's day, when the light was warm and orange. As you can see, if I'd relied on the camera's Auto white balance, setting that lovely warmth would have been drained—the picture wouldn't have been "wrong," but it wouldn't be what I wanted either. The Cloudy preset (opposite) is my preferred option, as it not only retains the warmth of the scene as I experienced it, but also enhances it a little.

Cloudy

CUSTOM

If Auto white balance refuses to play ball and/or there isn't a preset to help (or you simply demand absolute precision), then you need to turn to your camera's more advanced white-balance options. Some cameras will let you set the white balance manually, usually by dialing in a specific color temperature between 2000K and 10,000K (sometimes in increments as low as 100K). For most of us, this is a pointless exercise. Why? Well, look out of the nearest window right now and tell me what the color temperature of the light is—to the nearest 100K. Unless you happen to have a color meter on hand, which will tell you that exact measurement, then your guess—no matter how educated—probably won't be correct. Sorry, that's just the way it is.

Instead, you will be better served if you set a custom white balance. The actual "how" of the process will depend on your camera, but usually it involves photographing a white or neutral gray target under the same lighting conditions as

your subject. The camera analyzes the color of the target, and from that information, knows how it needs to shift the white balance to deliver a color-neutral result. You can then set this as your custom white balance.

Although a custom white balance is arguably the most accurate white-balance option, it does suffer from two slight drawbacks. The first is that it only applies to the lighting the target shot was taken in, so if the lighting changes, the white balance also needs to change. This could be the result of an obvious change in lighting (moving from daylight outdoors to artificial lighting indoors), or it could be more subtle (a cloud passing in front of the sun). Second, you need to be sure that your test target is perfectly neutral, as the slightest tint will affect the white balance.

BELOW: For this shot, I deliberately dialed in a high color temperature to intensify the apocalyptic sunset over this oil refinery (although additional post-processing color work was also needed).

RAW POWER!

As you've just seen, there are numerous ways that you can use your camera's white balance setting to (hopefully) get a color-neutral image. These are all useful when you shoot JPEG, but as alluded to earlier, if you shoot Raw, setting the white balance in-camera becomes more optional. It's still worth spending time getting it right, but if for whatever reason that's not possible, you can adjust or reset the white balance when you process your Raw file.

Most software will have a similar range of options to your camera, including white-balance presets, such as Daylight, Cloudy, Incandescent, and so on; a color-temperature scale that allows you to set a precise Kelvin value; and you will also find an Auto setting that allows the software to assess your image and decide what it thinks the white balance should be.

Your Raw-conversion software is also likely to have some sort of white-balance tool (or "gray picker") that will let you click on a point in the image that should be neutral gray. As soon as you do, that point will be neutralized, and any cast removed from the image. Of course, it helps if you have something in the scene that should be gray, which is where a gray card can come in handy. This is a neutral card that you put in your scene, photograph, and then remove before you make your "proper" exposure. This will mean you have two shots: one with the gray card and another without. In your Raw converter, you can open both images and use the shot with the gray card as a white balance reference for the "proper" exposure, guaranteeing absolute neutrality.

Warmer

Cooler

TOP: Shoot Raw and you can fine-tune the white balance of your images at the processing stage, making them warmer (above left) or cooler (above right), or to get a different result entirely.

WHEN "RIGHT" IS "WRONG"

So far we've been talking about white balance in terms of "right" and "wrong," as if there's only one aim—to alleviate any color bias and produce a photograph with colors that are true to the scene we witnessed. For the majority of our shots this type of "record of reality" is precisely what we are after, but it shouldn't be seen as the only option. Intentionally setting the "wrong" white balance can be a great way of transforming a scene and elevating the ordinary to the extraordinary.

There are several ways that you can alter the color of your images, the simplest being to deliberately choose an inappropriate white-balance preset. If you're shooting outdoors, then setting the white balance to Incandescent (Tungsten) will result in a strong blue color cast, which can work particularly well with misty landscapes, or enhance the feeling of cold in a wintry scene. Alternatively, head indoors and set a Daylight white balance under tungsten lights for a heavy orange glow—it won't work with every subject, but every so often it might add something special.

An alternative approach is to use your camera's custom white balance, but instead of using a neutral target, use a colored target instead. The thing to remember here is that your camera will want to add the opposite color to your target to neutralize the color. So, if you used a red target for your custom white balance, the camera would add green; use a green target and it would add red to your images. Again, you might not get a stunning result every time, but there's no harm experimenting—photography is as much art as it is science, and art is rarely created with a rule book.

LEFT & OPPOSITE: To make this shot, I set a slow shutter speed and tilted the camera during the exposure, panning it up some tree trunks to create an abstract image (left). As I shot Raw, I could manipulate the white balance (amongst other things) when I processed the image, enabling me to create a number of color variants (opposite), some more realistic than others.

BEYOND WB

When you start to take control of your camera, you'll find that there's slightly more to color than white balance. There are two other color concepts that you need to familiarize yourself with: picture styles (which might also be called "Picture Controls" or "Creative Styles" depending on the badge on your camera) and color space.

PICTURE STYLES

As the name suggests, picture styles are preprogrammed treatments for your photographs, which give them a specific "look." Picture styles are easily confused with Scene modes because the two often have similar names—you'll probably have a Landscape Scene mode, as well as a Landscape picture style, and Portrait options for both as well. However, picture styles are not concerned about exposure, as Scene modes are. Instead, they are all about the "look" of your images.

The commonly encountered options are Standard, Neutral/Natural, Vivid, Landscape, Portrait, and Monochrome. With the exception of Monochrome (more on that later), each style offers a different blend of saturation, hue, contrast, and sharpening. When you call on a picture style, you're determining whether you want more or less color intensity; a slight shift to make your images warmer or cooler; to have more or less contrast; and to what extent detail should be sharpened in-camera. As well as the defaults, most cameras will allow you to dip in and fine-tune the settings of each, and there's usually an option to create custom styles as well, so if you're willing to put in the time and effort, picture styles can help you create an individual "signature style."

However, you might not want to get too carried away. As with white balance, picture styles are really only important if you're shooting JPEGs, as they're all about how the image is processed by the camera. If you shoot Raw, the settings can be undone, changed, and reapplied on your computer if you use the software that came with your camera; if you use different Raw-conversion software, then it's unlikely you'll be able to access picture styles.

Standard

Neutral

Vivid

Portrait

Landscape

Monochrome

Converted Raw

ABOVE: Picture styles allow you to quickly set an overall "look" for your image based on several parameters. Most cameras come with a core set of styles, like those above, although picture styles can typically be edited in-camera. Picture styles can also be created using dedicated style-editing software (if this comes with your camera) and then installed in your camera for use. However, this only applies if you shoot JPEGs; if you shoot Raw, you can create, save, and edit your own styles at the processing stage.

COLOR SPACE

In the simplest sense, a "color space" is a range of colors (known as the space's "gamut"). It could be the range of colors that your printer can print, that your monitor can display, or that your digital camera can record. Most cameras offer a choice of two color spaces—Adobe RGB and sRGB.

As shown below, AdobeRGB has a wider gamut than sRGB, which means it can record a greater range of colors (most notably in the green areas). AdobeRGB is good for shots that are going to end up printed in a book or magazine, because it's a close match to the CMYK color space used in that type of printing. It's also technically "better" if you intend to edit your images extensively, as there are more colors to play with.

But—and this is a big BUT—most computer monitors and "proper" photo printers (the type you would find at your local photo store) have a color space that's smaller even than sRGB. This means that if you're going to print your images at your local photo store, or you intend to post them online—essentially those things that a lot of us do—then sRGB is a "better fit." Sure, you can use AdobeRGB, but you'll have to switch the image to sRGB in your editing software to "squash" the colors down, otherwise the colors

LEFT: The AdobeRGB and sRGB color spaces lie within the all-encompassing CIELab color space, which contains every color we can theoretically perceive. AdobeRGB is the larger of the two photographic color spaces, although sRGB is (arguably) the easiest option to work with.

OPPOSITE: There is a very subtle difference in certain colors in the background of this image, depending on whether it uses the sRGB (top) or AdobeRGB (bottom) color space. However, this will only ever be seen when the images are side-by-side, and that's not how they'd normally be seen. Viewed individually, neither shot is significantly "superior" to the other, so as the sRGB variant would be easier to print accurately that would ultimately be the option I'd work with—I might lose a couple of hues, but no one would ever notice.

you see can look flat and drab. This isn't a huge effort, but if your images are only going to be seen online or as a print from your local print shop, then life is simpler in sRGB.

Even if you aspire to be seen in print, then most of the time you might not actually notice any difference between the two spaces. Some of the images in this book were shot as sRGB, and some are AdobeRGB—can you tell which is which? I'm not even sure I can now...

SHADES OF GRAY

There's something inherently "artistic" about black-and-white photographs, perhaps because they exude a timeless, classic vibe that references the origins of photography, almost two centuries ago.

Although we'll look at the technical issues surrounding black and white on the following pages, it's worth noting that the decision to produce a black-and-white image always needs to be subject led. At a base level, some subjects suit color photography far more than black and white, simply because color can be such an integral part of the scene. Think urban graffiti and wall art; neon city lights at night; or a stunning sunset, for example. Each one of these gains impact through strong colors—take that away and the image can quickly lose its entire raison d'etre. At the same time, documentary and street photography can gain gravitas from being shot in black and white, as if shades of gray are somehow more "honest." And between these extremes are shots that might work equally well both with and without color.

However, getting a good black-and-white shot depends on a lot more than simply removing the color—not only do you need to know how to best remove the color from your image, but also when to drain it.

OPPOSITE TOP: Some shots are all about the color: this Tokyo street scene gets its impact from the colored neon lights.

OPPOSITE BOTTOM: In other instances, a black-and-white treatment is obvious: this triangular staircase is almost monochromatic by design.

LOSING COLOR

When you want a black-and-white photograph, your choice is simple: you either shoot in black and white (using your camera's Monochrome picture style), or you shoot in color and convert to black and white on your computer.

However, despite the potential appeal of black and white, when you shoot Auto or use a Scene Mode, it isn't usually an option, because the picture style is either preprogrammed (when you use a Scene Mode) or selected automatically for you (Auto).

It's a similar story when you shoot Raw, but for a very different reason. You might be able to choose the Monochrome picture style and shoot black-and-white Raw images, but they only become *permanently* black and white when they're processed on your computer. Until then, you can undo the effect and switch your images back to full color, just as you can change the white balance, contrast, exposure, and so on.

So, from the very start, shooting black and white in-camera is worth considering only if you shoot JPEGs and are using either Program, Aperture Priority, Shutter Priority, or Manual mode. Even then, I'd only recommend it if you are adamant that you will only ever want a monochrome shot, or you want to print your images straight from your camera, or you refuse to do any post-processing on a computer—if not, you may be better served shooting in color and converting your images to black and white later on.

OPPOSITE: When I took this snowy street shot, I was fairly certain it would end up in black and white. However, I shot it in color (and in Raw) so I had maximum flexibility—the black and white I envisaged (top left), plus color options.

MONOCHROME PICTURE STYLE

If in-camera black and white is for you, then your camera's Monochrome picture style will give you a certain amount of control over your black-and-white shots. Instead of saturation and hue options, the Monochrome picture style will give you options for filters and toning:

Filters: The Monochrome filter options attempt to replicate the use of color filters in front of the lens, which was (and still is) how old-school black-and-white shooters control the way in which different colors are transformed into shades of gray. The idea is simple: colors in the shot that are the same (or similar) color as the filter will appear brighter, while colors on the opposite side of the color wheel will appear darker. Applying a red filter effect will lighten the reds and dark oranges in a scene when they're turned to gray, and darken the blues—a great way of creating dramatic black skies with contrasting white clouds.

Toning: In-camera toning gives your images an all-over color tint. The "classics" here are sepia and blue, emulating the most popular traditional black-and-white print toners, but some cameras expand the color range to include green, purple, red, and other equally unnatural hues. Although you can adjust the intensity of the colors, there's really very little to recommend in-camera toning—the colors are usually crude, and rarely improve a shot. Just pretend this is something your camera can't do.

OPPOSITE: A warm, sepia tone can immediately imbue an image with a "classic" feel, but it is better to add a tone using your editing software, rather than the typically primitive in-camera coloring options. Here, a traditional brown tone was joined by faux processing stains, grain, and an instant film-style border.

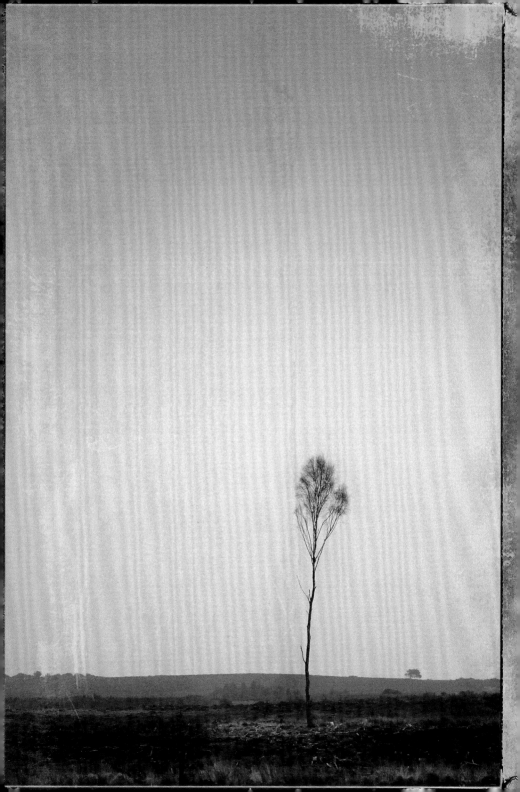

SOFTWARE CONVERSION

If your photographs are going anywhere near a computer and editing software (which, let's face it, most do) then by far the best option is to shoot in color and convert your pictures to monochrome during post-processing. This has two significant advantages, the first of which is quite simple— you will have a color option as well, without having to shoot and save two images.

The second advantage comes at the conversion stage, which relies on your image-editing software. Most decent image-editing software (think Photoshop, Elements, Lightroom, PaintShop Pro, and GIMP) has black-and-white tools that are far more sophisticated than your camera's Monochrome mode. This usually means a more expansive set of color filters to manipulate the tones when you convert them to gray; the ability to combine and adjust those filters; and the ability to target the filters to specific parts of the image through the use of masks and selections.

In short, software will enable you to create color filter combinations that go way beyond anything that is possible in-camera (or when shooting traditional black-and-white film), and then apply them in ways that are also impossible to achieve any other way.

LEFT: With your image open in your editing software you have a whole host of tools at your disposal, allowing you to create (and recreate) a wide range of mono effects, such as this high-contrast "lith" treatment.

COLORED FILTERS

A decent image-editing program will let you use digital "filters" when you convert an image to black and white. This is designed to emulate the colored filters used over the lens with traditional black-and-white film, which control how the colors convert into shades of gray.

Colored filters work by lightening colors that are the same or a similar color to the filter (when they are converted to shades of gray), while darkening the colors sitting opposite the filter's color on a standard color wheel.

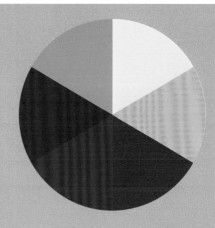

Filter	Lightens	Darkens	Typical uses
Red	Reds, oranges, and some violets	Blues and greens	To darken a blue sky in a landscape and enhance contrast between the sky and the (white) clouds
Yellow	Yellows, oranges, and some greens	Blues and violets	As above but less extreme
Green	Greens and some blues / yellow	Reds	To lighten the appearance of foliage (useful for increasing the contrast between a flower and any leaves)
Blue	Blues and some greens / violets	Reds, oranges, and yellows	Not a traditional black-and-white filter, but it may work for your shot, so why not give it a go?

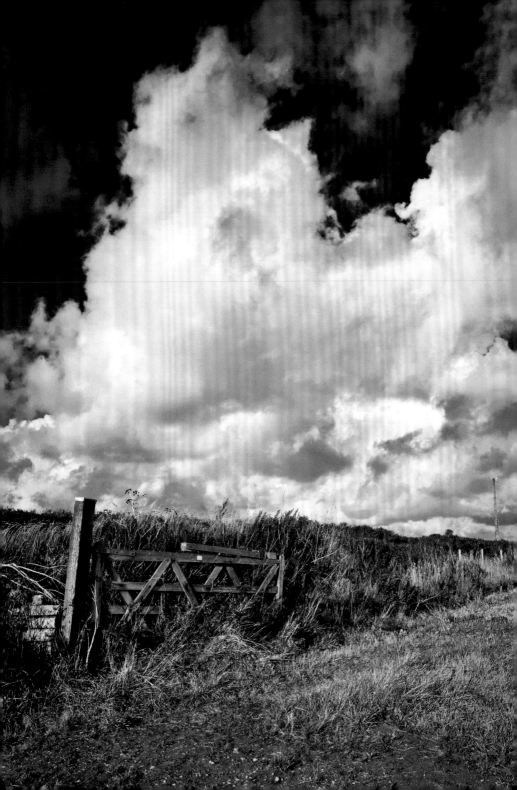

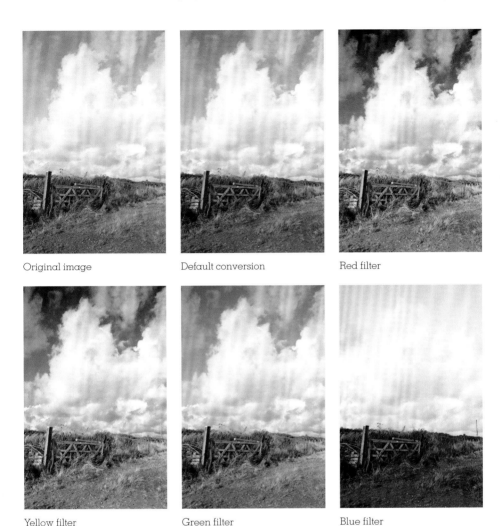

Original image Default conversion Red filter

Yellow filter Green filter Blue filter

ABOVE & OPPOSITE: As outlined on the previous pages, good editing software will let you apply "digital colored filters" when you convert your images to black and white. Often, there is a far greater range of colors than traditional filters ever offered, allowing far greater control over the end result. For example, the main image (opposite) started with two black-and-white conversions of the same photograph: a red-filtered conversion to bring out the sky and a default conversion for the foreground. The two were then combined in a way that would have been exceptionally challenging to achieve in a traditional darkroom.

BACK TO COLOR

Although in-camera toning effects are just plain nasty, there's no reason why you can't reintroduce color to your black-and-white shots using your editing software. Again, the level of control you have here exceeds anything that can be achieved in the traditional darkroom.

With traditional mono prints, toning was necessary for technical reasons—the chemicals used in toning processes were chosen because they made prints more lightfast, so they wouldn't fade too quickly. The color was of secondary importance. However, with digital photography it's a purely cosmetic choice, with color choice now the main concern.

LEFT: This image was shot on black-and-white film and printed on a warm-toned paper. I then gave it a similar warmth when I scanned the negative and processed the image digitally.

The obvious toning choices are the colors that mimic the tones of the past—sepia can immediately give your shots a vintage vibe, while blue is reminiscent of the classic cyanotype process. In both cases, matching the tone to the subject is a good idea, as there can be a distinct "disconnect" between a modern subject and a classic tone.

The best advice here is to experiment. Try treating the same image with different colors to see if one works better than the rest. If it does, ask yourself why. Also, if you're going for a vintage feel, don't just stop at toning: adding faux film grain, some faked dust and scratch marks, vignetting, perhaps a "filmic" border, and maybe a touch of soft focus can all add to the idea that your shot wasn't taken a couple of hours ago on the latest and greatest digital SLR.

RIGHT: The cool blue tone complements the shadows and adds an icy mood to this shot.

Of course, you don't have to stick to single colors. Split toning is often employed in both the traditional and digital darkroom as a way of introducing different colors into the shadow and highlight areas. Cool blue shadows and warm yellow highlights are the most common split, as we not only think of shadows as being "cool" in tone, but blue and yellow naturally complement one another, adding color contrast to an image.

You don't always have to fall back on the "classic" colors, either, as your image-editing software will allow you to pick any other color you can think of to tone your images. Tread carefully, though—just because you can choose a specific color, that doesn't mean you should. It's hard to imagine why or how a purple tint could be used to genuinely improve an image.

Saying that, don't be afraid to use less conventional colors for your mono images. However, rather than toning the existing shades of gray with insipid hues, why not go bold and saturated instead? Use layers of flat primary colors in your image-editing program and boost the contrast of the image beneath. This will create a distinctly modern look that puts the "graphic" into photographic, taking you way beyond Auto in the process.

ABOVE OPPOSITE: Go bold! The color you add to your mono shots doesn't have to be "natural" to create great-looking images!

OPPOSITE LEFT & RIGHT: The blue/yellow split tone and a dark vignette transforms this shot of a decorative church detail in Sicily.

GLOSSARY

Angle of view: The amount of a scene that a lens can "see" and record to your sensor. Wide-angle focal lengths have a wide angle of view, so project more of the scene onto your sensor, while telephoto focal lengths have a narrower angle of view, effectively magnifying a smaller part of the scene you are photographing.

Aperture: A "hole" within a lens that regulates the amount of light that can pass through. The aperture is usually variable, enabling you to let more or less light through the lens. The aperture also plays a fundamental role in determining the depth of field in a shot.

Aperture priority: A shooting mode where you select the aperture you want to use (usually because you want to control depth of field), and the camera selects what it feels is the best shutter speed to give the "correct" exposure.

Auto-Exposure Lock (AE-L): A feature found on most cameras that enables you to lock the exposure, usually before reframing a shot. Can typically be achieved using a dedicated button, or by pressing (and holding) the shutter-release button down halfway.

Autofocus (AF): The camera moves elements within the lens to bring the scene (or part of the scene) into focus on the sensor. Once a slow and noisy process, autofocus (AF) is now the primary focusing method for most people, thanks to fast focusing motors and accurate AF sensors.

AutoFocus Lock (AF-L): Similar to Auto-Exposure Lock, although this feature enables you to lock the focus, rather than exposure. Again, you would typically do this before reframing a shot, either by using a dedicated button, or by pressing (and holding) the shutter-release button down halfway. AF-L and AE-L are often locked at the same time, so you may need to explore your camera's menu if you want to "unlink" them.

Auto mode: You're better than that.

Bracketing: Usually applies to exposure, where a number of photographs are taken at different exposure settings to give a range of brighter/darker options, as well as the nominally "correct" result. Bracketing can either be done manually using exposure compensation, or using your camera's automatic exposure bracketing (AEB) facility (if it has one). Many DSLR and mirrorless cameras also allow you to bracket the white balance.

Center-weighted metering: Exposure metering pattern that reads the light from the entire image area, but biases the exposure toward the center of the frame. Useful for photographing central subjects surrounded by a very light or very dark background.

Clipping: When highlights in a photograph become pure white or shadows become pure black they contain no detail. At this point they are said to be "clipped."

Color cast: When an image has an overall color tint, typically caused by an incorrect white balance setting (although this can be used intentionally to color an image).

Color temperature: Light has a "temperature," which is measured using the Kelvin (K) scale. The lower the temperature, the warmer (more orange) the light is. For example, daylight nominally sits at 5500K; incandescent (tungsten) light is warmer at around 3300K; and open shade is cooler, at approximately 8000K. Other lighting conditions will typically fall somewhere in the range 2000–10,000K.

Dynamic range: The range from the brightest to darkest parts of a scene. Also, the range from bright to dark that a camera can record detail in, usually measured in stops. When the dynamic range of a scene is greater than the dynamic range of the camera, the shadows or highlights will be clipped.

Exposure: To make an exposure is to allow light to reach the sensor in your camera. How much light you expose the sensor to, and how long you expose it for, is the cornerstone of photography. However, don't get sucked into thinking there's such a thing as the "correct exposure"—the right exposure is simply the one that matches your vision.

Exposure compensation: A camera function that allows you to adjust the exposure recommended by the camera, either because

you know your picture-taking box has got it wrong, or you simply want a lighter or darker look. Use positive (+) exposure compensation to make images lighter; negative (-) exposure compensation to make them darker.

f/stop: Used to denote the size of the aperture in a lens (f/2.8, f/4, f/5.6, and so on). F/stops are fractions of the focal length.

Fill flash: A technique that mixes flash with the available ("ambient") light. Fill flash can be subtle (to lift shadows on a face, for example), or more obvious (to create a "day for night" look).

Focal length: Technically,the distance between the optical center of a lens and the focal point (sensor) when the subject is focused at infinity. However, in the real world it indicates the viewing angle of a lens: the shorter the focal length (18mm and 21mm, for example), the wider the viewing angle; the longer the focal length (150mm and 200mm, for example) the narrower the viewing angle.

Gray card: A card that is the same tone as the 18% gray that a camera's exposure meter is calibrated for. Can be used for taking accurate spot meter readings and setting white balance.

Histogram: A graph showing how the tones in an image are distributed. Useful for gauging exposures in-camera, as it is more reliable than the rear LCD screen, which can be affected by the ambient light (the rear screen will look brighter in low-light conditions and darker in bright conditions).

Hotshoe: An electronic flash connection found on top of most DSLR cameras and many mirrorless cameras (with the exception of some older Sony cameras). A main contact on the hotshoe is used to trigger the flash (this is common to all cameras), while additional contacts are used for proprietary ("dedicated") features, such as automatic flash control.

Image stabilization: A prevalent technology used to counter camera shake. There are currently two options used by camera manufacturers: sensor-shift stabilization and lens-based stabilization. Each has its advantages and disadvantages, but both

are better than no stabilization when you're shooting handheld and the light level is low or the shutter speed is slow.

ISO: A throwback to film, which used ISO speed to indicate the sensitivity of the film to light. Today, ISO is used to give a comparable indication for a digital sensor.

JPEG: A file type that processes the image in-camera, then compresses the image data to make file sizes smaller. To achieve this, some of the data is discarded permanently: at low compression/high quality settings this may not be noticed, but artifacts can start to appear in images that have been heavily compressed (or opened and resaved/recompressed repeatedly).

Manual focus (MF): To focus the lens, you turn it by hand. It may seem like an old-fashioned approach, but in some situations MF can be quicker and more accurate than using AF.

Manual mode: You set the aperture, shutter speed, and ISO. Gives you absolute control over the exposure (and no one but yourself to blame if it's wrong).

Multi-area metering: The name varies from manufacturer to manufacturer (Evaluative, Multi-pattern, Multi-segment, and so on), but the principle is broadly the same: the camera divides the scene to be photographed into multiple areas or segments, and meters each of these individually. The results are then averaged out—often with some form of "intelligent" processing working behind the scenes to guess what you're pointing your camera at—to determine the overall exposure.

Noise: Non-image-forming artifacts that appear in an image at high ISO settings and/or when long exposures are made. There are two types of noise—chroma noise, which appears as red, green, and blue colored speckles in an image, and luminosity noise, which appears as an underlying "gritty" texture.

Noise reduction: In-camera or software-based process designed to counter the effects of noise. There will typically be separate options to deal with noise caused by high ISO and long exposures, but both need to be treated with

care—set at an overly aggressive level they can start to remove detail from images, as well as the noise.

Overexposure: When an image is brighter than you want, either because the aperture is to wide, the shutter speed is too long, and/or the ISO is too high. Deliberate overexposure can create a "light and airy" look to your images.

Picture style: Also known as Picture Controls, Creative Styles, Picture Modes, and Custom Images, depending on the make of your camera. These are preset options that offer a selection of color effects, from bold and vivid, to subtle and less saturated. Only applicable if you shoot JPEGs—the picture style of a Raw file can be changed or removed when you process the file.

Pixel: The smallest building block of a digital image, short for "picture element."

Prime lens: A lens with a single, fixed focal length. Although they are now widely over-looked in favor of zoom lenses, prime lenses have several benefits, such as wider maximum apertures, light weight, lower cost, superior image quality (sometimes), and usually better ergonomics for focusing manually.

Program mode: The camera sets the aperture and shutter speed, but you have the option of adjusting the paired settings if, for example, you want to use a faster shutter speed or smaller aperture than the camera suggests. Program is a great way of exploring the basic relationship between aperture and depth of field and shutter speed and movement, while still letting the camera control the overall exposure.

Raw: A file type that consists of the "raw," unprocessed data captured by the camera's sensor. This makes it the "purest" (and potentially highest quality) image a camera can record, although an additional processing stage is needed when the images are downloaded to your computer.

Red-eye: A phenomenon caused when the light from a flash enters a person's eye, and reflects off their retina when a photograph is taken. The result is the once-black pupil becomes red due to the light bouncing off blood vessels at the back of the eye. Typically caused when a flash is in close proximity to the lens, and is aimed directly at the subject (who in turn is looking straight back down the lens).

Shutter: The mechanical (or electronic) device in a camera that opens to allow light to reach the sensor, and closes to end the exposure.

Shutter priority: The opposite of Aperture priority. In this shooting mode, you select the shutter speed you want to use (typically because you want to freeze or exaggerate movement in an image), and the camera selects what it feels is the best aperture to give the "correct" exposure.

Shutter speed: The time the shutter is open, exposing the sensor to light.

Spot meter: A metering pattern that assesses a very small part of the scene to determine the correct exposure. Can be super-accurate, but practice is needed to make sure your reading is taken from midtone area (or you can use a gray card)

Stops: One stop is equal to the doubling or halving of light in an exposure, whether that's achieved using the aperture, shutter speed, or ISO.

Underexposure: When an image is darker than you want, either because the aperture is too small, the shutter speed is too fast, and/or the ISO is too low. Deliberate underexposure can create a "dark and moody" look to your images.

White balance: Tool used to adjust the color response of the sensor to match the color temperature of the light, thereby ensuring that "white is white." It can also be used to intentionally introduce color shifts into your images. More important when you shoot JPEG files, as the white balance can be changed easily when you shoot Raw.

Zoom lens: A lens that covers a range of focal lengths. The main advantage is that you don't need to change lenses to change your angle of view.

INDEX

ACKNOWLEDGMENTS

This book—like many others—wouldn't have happened without the folks at Ilex (Roly, Adam, Frank, Natalia, Julie, and Rachel), so thank you all for the part you've played in getting this to print.

Thanks also to Marko Saari and Grant Rogers for allowing me to use their images: you can see more of their work at www.markosaari.carbonmade.com and www.flickr.com/photos/grantsrogers respectively.

I'd also like to thank you for reading this far (I'm hoping you didn't start at the end of the book!). I really hope these pages will encourage you to switch your mode dial away from Auto and inspire you to start taking control of your photography—with a digital camera there really is nothing to lose except time and patience.

Finally, love as always to N, T, and GM, who do their best to keep me sane, as well as the three monsters—Lemmy, Halle, and the "old man," Pepster—who don't. And N? You really are running out of excuses not to go beyond Auto. That "proper" camera's still waiting...

PICTURE CREDITS

·All photographs © Chris Gatcum, with the exception of:

Tatiana Dean: 12T

iStockphoto (www.istock.com): 45 kjohansen, 56T franckreporter, 64 Peeter Viisimaa, 67T freemixer, 67B Ramonespelt, 72 knape, 73 Monsieur_Wizz, 74 ivosevicv, 89 baona, 91T 2630ben, 95B garyforsyth, 107 hh5800, 108 miappv, 113 olaser, 127T kitchakron

Grant S. Rogers (www.flickr.com/photos/grantsrogers): 77

Marko Saari (www.markosaari.carbonmade.com): 76

Shutterstock (www.shutterstock.com): 50 Igor Stramyk, 71 LoloStock